Zen Patterns and Designs

Coloring for Artists

Skyhorse Publishing

Skyhorse Publishing books may be purchased in bulk at special discounts for sales promotion, corporate gifts, fund-raising, or educational purposes. Special editions can also be created to specifications. For details, contact the Special Sales Department, Skyhorse Publishing, 307 West 36th Street, 11th Floor, New York, NY 10018 or info@skyhorsepublishing.com.

Skyhorse® and Skyhorse Publishing® are registered trademarks of Skyhorse Publishing, Inc.®, a Delaware corporation.

Visit our website at www.skyhorsepublishing.com.

10 9 8 7 6 5 4 3

Library of Congress Cataloging-in-Publication Data is available on file.

Cover design by Rain Saukas
Cover artwork credit: Shutterstock/Gorbash Varvara
Text by Arlander C. Brown III

Print ISBN: 978-1-5107-0460-2

Printed in the United States

Zen Patterns and Designs:
Coloring for Artists

Most of us have been coloring and drawing since before we can remember. We were given crayons or markers and allowed to see where our imaginations could take us. Soon, we were given our first coloring book, usually filled with our favorite cartoon characters. While some of us meticulously stayed between the lines and some of us scrawled wherever we saw fit, the time we spent coloring was vital to our maturation. Coloring books—and art in general— permitted us the opportunity to test the bounds of our creativity, while exercising our minds and letting us escape to other worlds.

However, as we aged, coloring books were put aside for other endeavors. They no longer interested us or we thought they were for little kids. We were wrong! Coloring books can be enjoyed by all ages and continue to have the same benefits. If fact, they are probably more beneficial to adults because they offer us the rare moment of relaxation, allowing us the opportunity to focus only on the image coming to life on the page. Coloring is also a healthy and creative medium that permits adults to express their feelings, similar to keeping a journal.

This collection of designs goes even further, bringing together an assortment of beautiful and meditative Zen patterns and designs specifically created for the more artistically inclined. The essential element of Zen Buddhism is found in its name, for Zen means "meditation." Zen teaches that enlightenment is achieved through the profound realization that one is already an enlightened being. This awakening can happen gradually or in a flash of insight (as emphasized by the

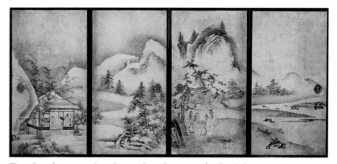

Zen landscapes (such as the above painting) began to appear when Zen art started to encompass a wider breadth of subjects.

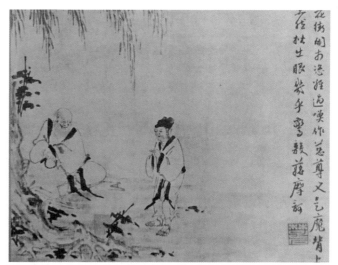

Traditional Zen painting that depicts two Zen patriarchs who have reached enlightenment.

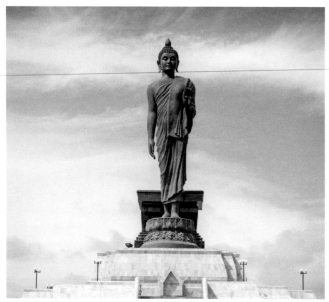

Buddha Image on blue sky, Thailand. More ornate than traditional Zen Buddhas that originate in China and Japan.

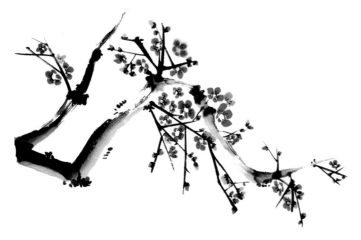

Traditional Zen watercolor painting of tree branch in full bloom.

Soto and Rinzai schools, respectively). But in either case, it is the result of one's own efforts. Deities and scriptures can offer only limited assistance. This does not mean that you will magically find enlightenment through coloring—but you could!

Originally, Zen monks painted in a quick and evocative manner to express their religious views and personal convictions. Their preferred subjects were Zen patriarchs and enlightened individuals. In time, however, artists moved on to secular themes such as bamboo, flowering plums, orchids, and birds, similar to many of the designs you will see in this book. The range of subject matter eventually broadened to include landscapes and fish, and the painting styles often became more important than personal expression. But, Zen art has maintained its meditative affects, as exhibited by the collection to follow. No matter how complex these designs become, you will feel an inherent sense of peace as you allow your mind to fill the page with color.

To make access to the inspiring art in this book easier, designs are printed on only one side of the page, and the pages are each perforated so they can be removed from the book. (This also allows you to hang your art upon completion.) There are also colored examples of each of the Zen designs that serve to further inspire your imagination, but this is not paint by numbers. The real fun of coloring is to use or own ideas and colors. So be brave and explore and see where your mind takes you!

1

2

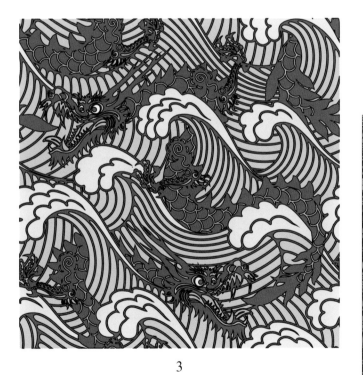

3

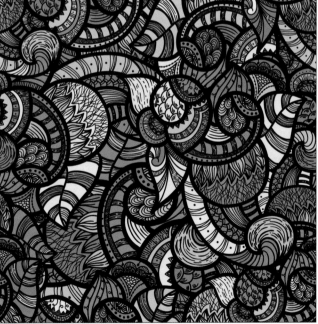

4

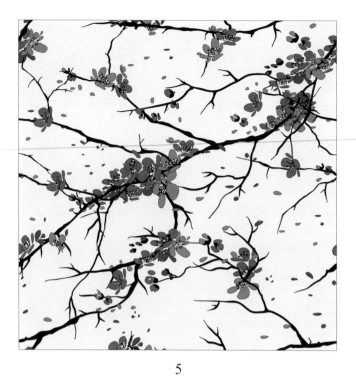

5

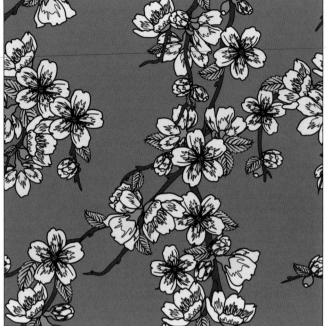

6

7

8

9

10

11

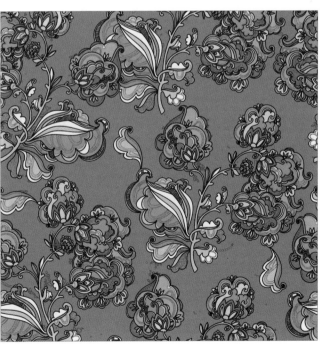

12

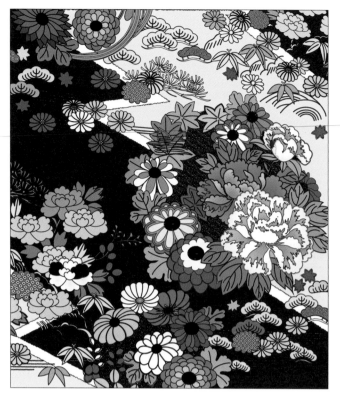

13

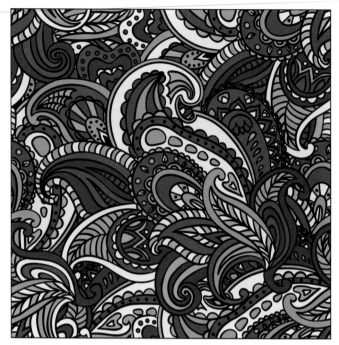

14

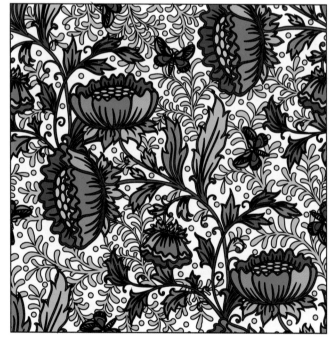

15

16

17

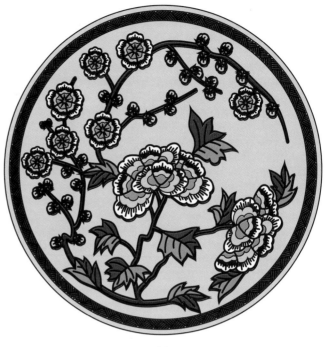

18

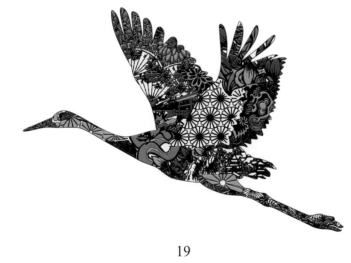

19

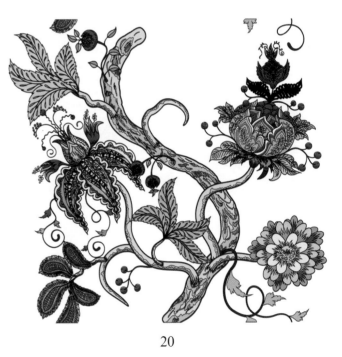

20

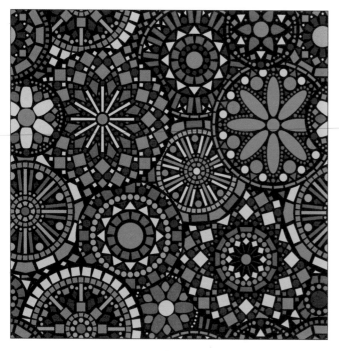

21

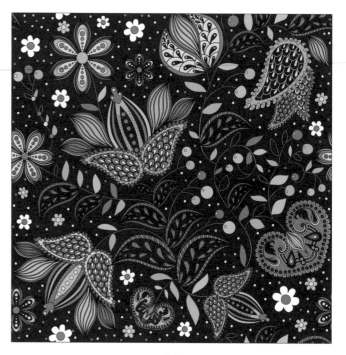

22

23

24

25

26

27

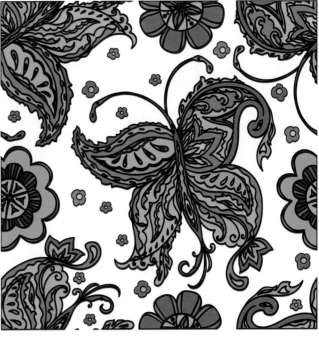

28

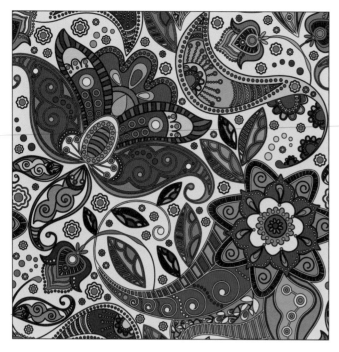

29

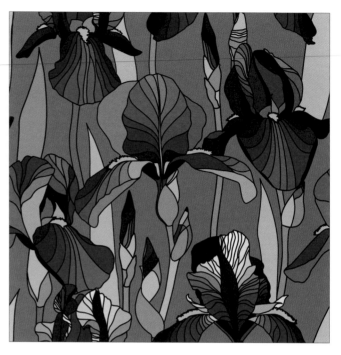

30

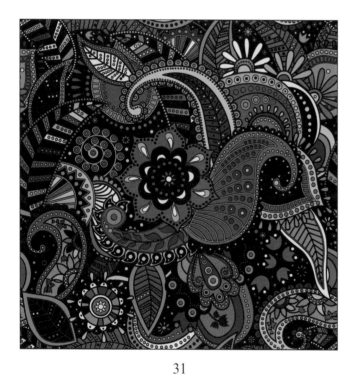

31

32

33

34

35

36

37

38

39

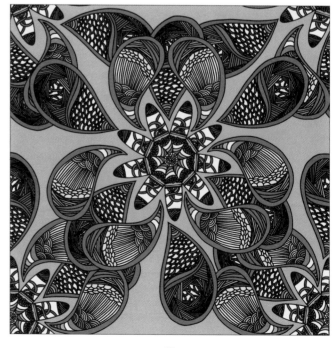

40

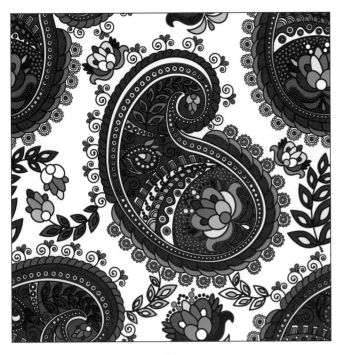

41

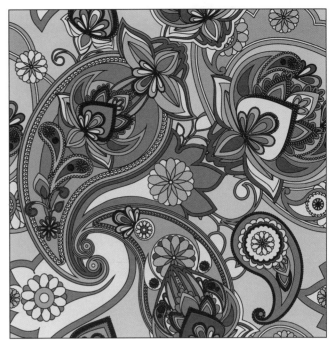

42

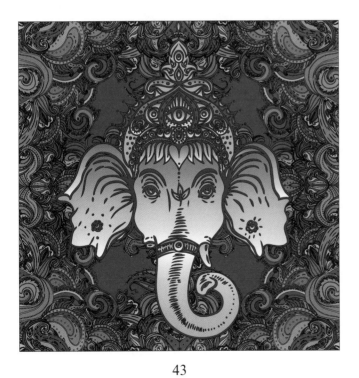

43

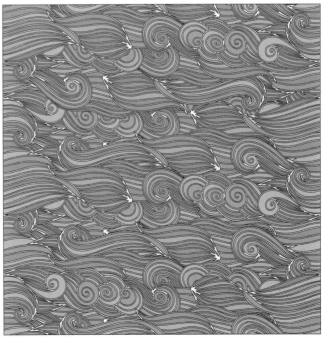

44

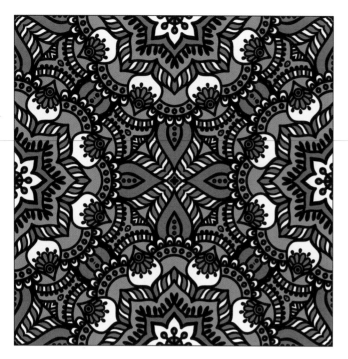

45

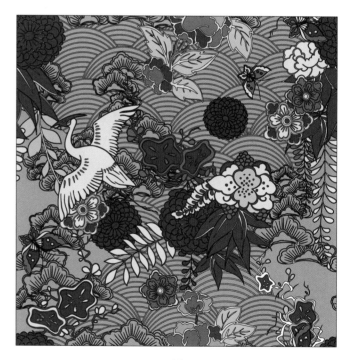

46

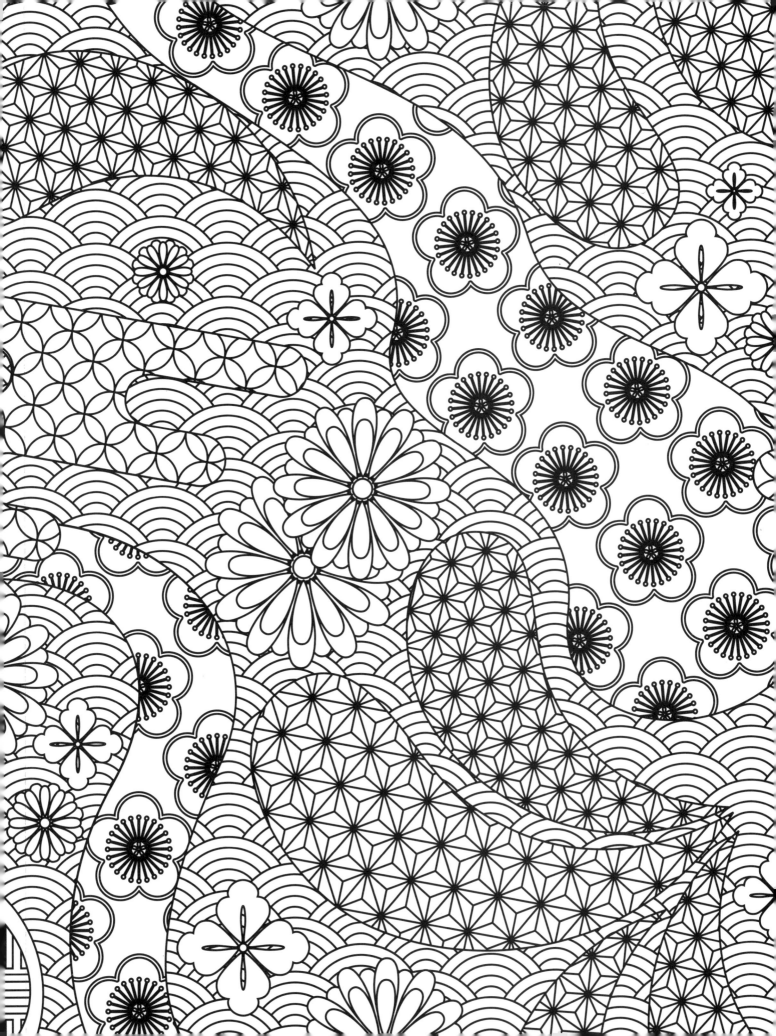

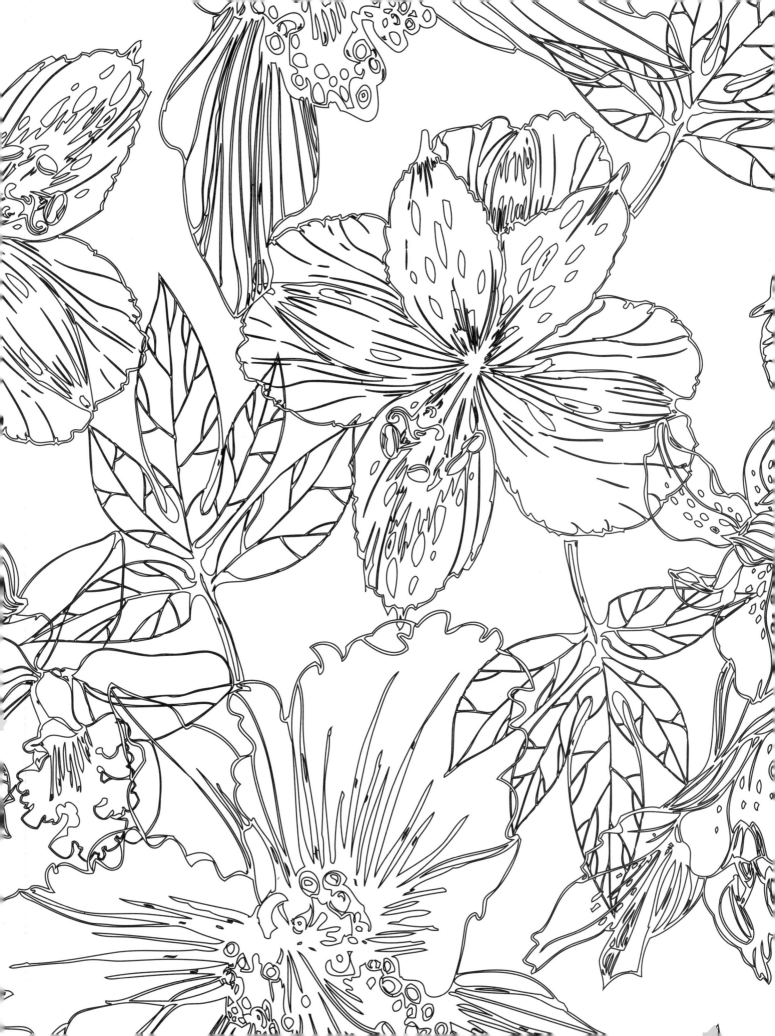

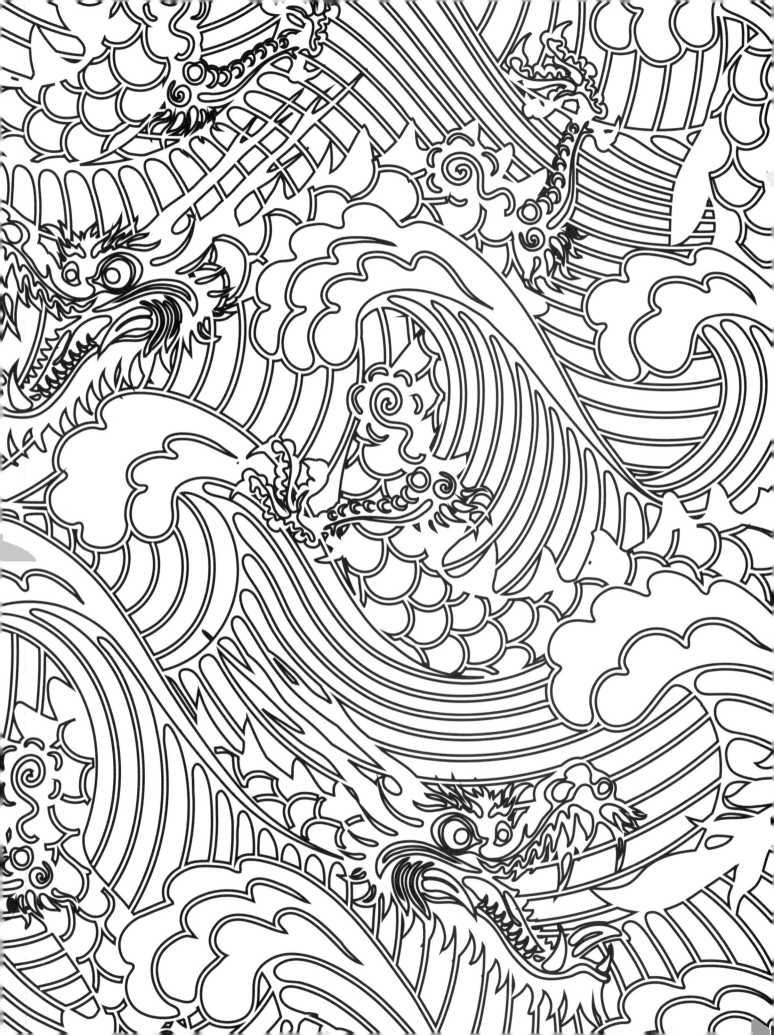

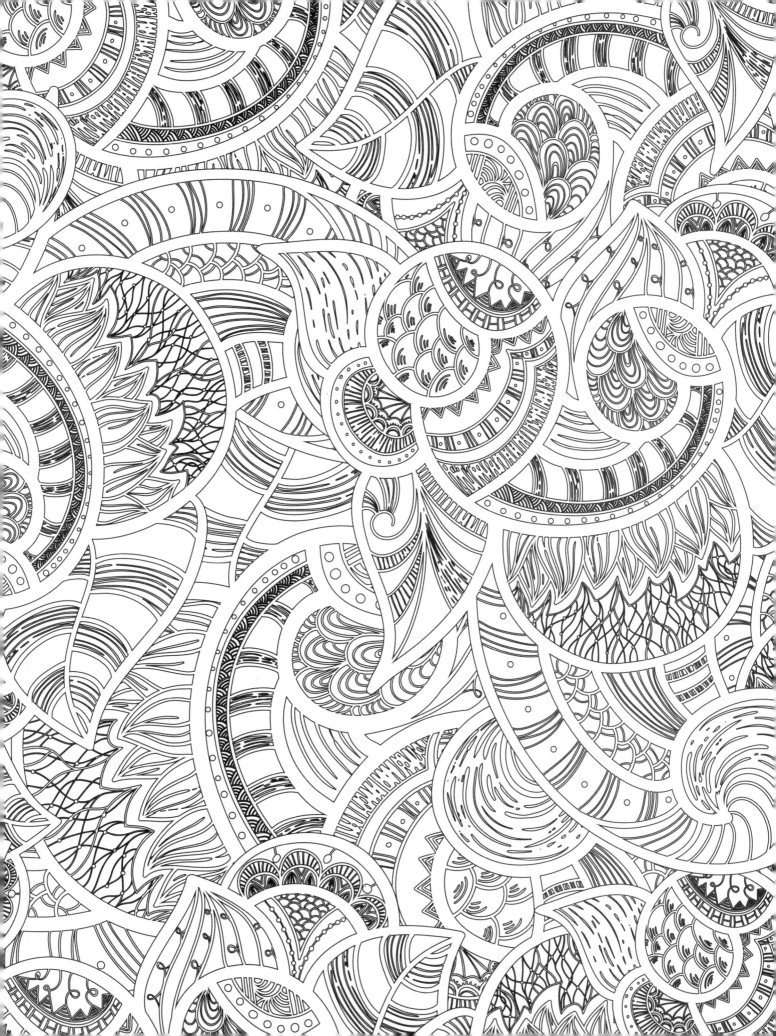

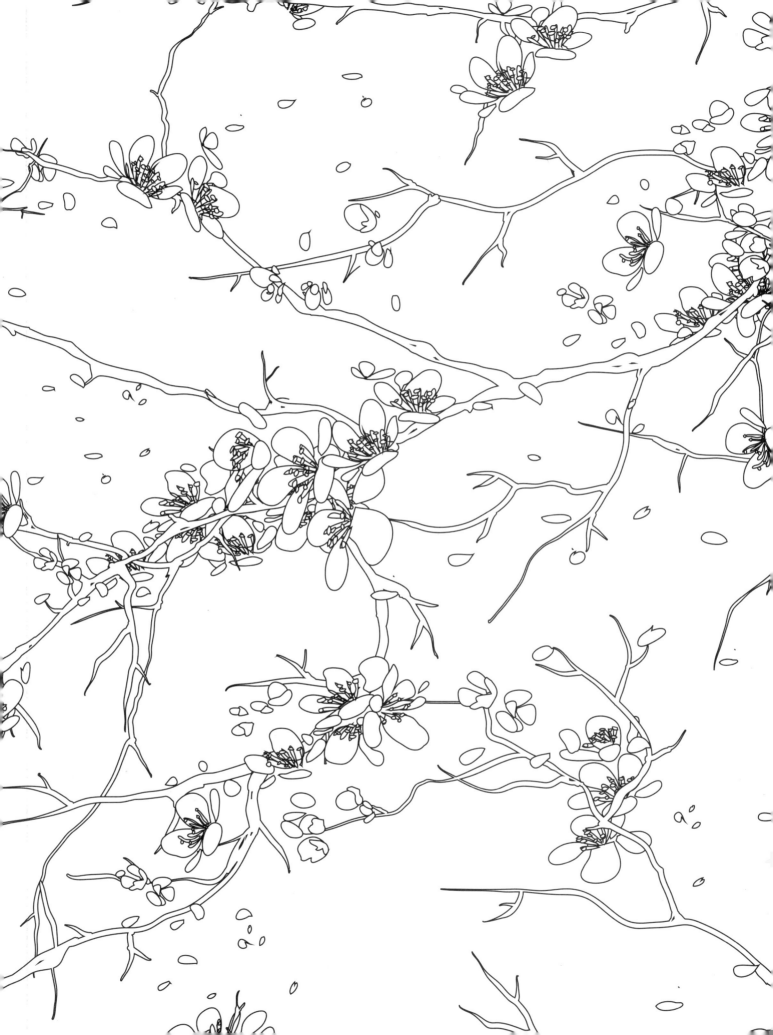

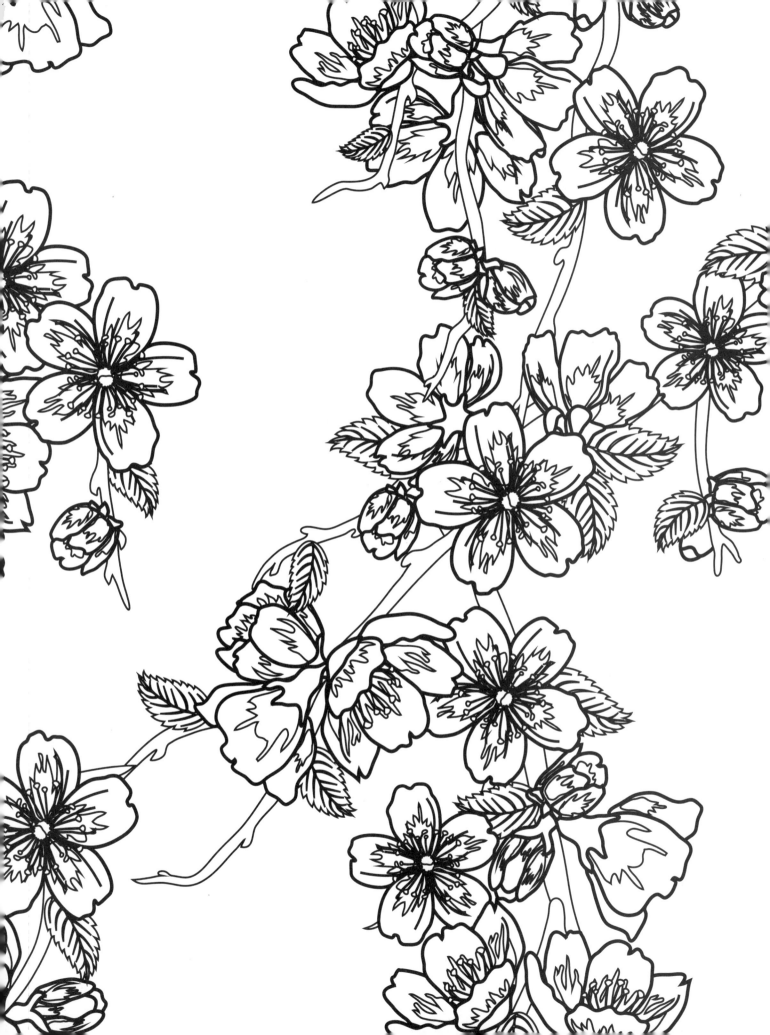

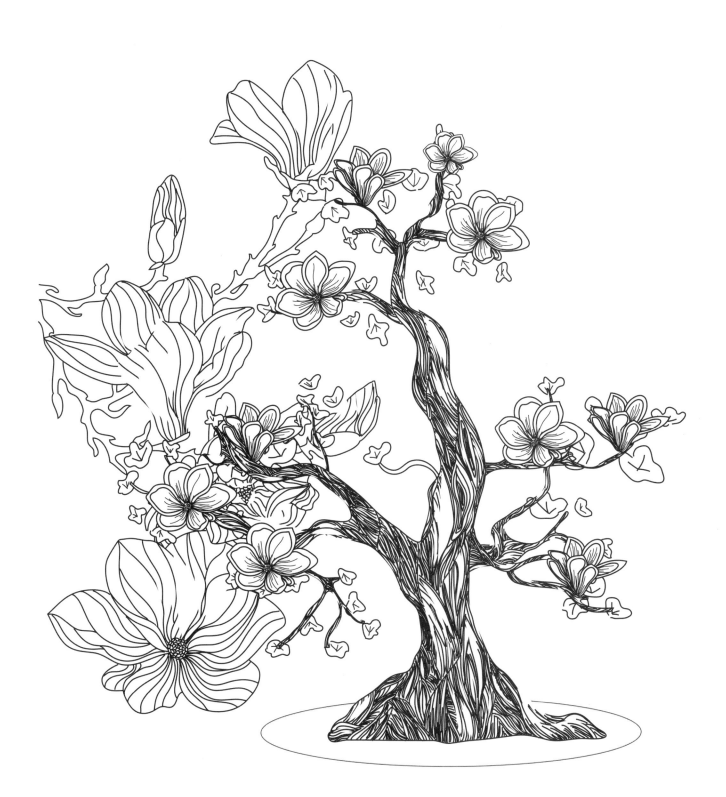

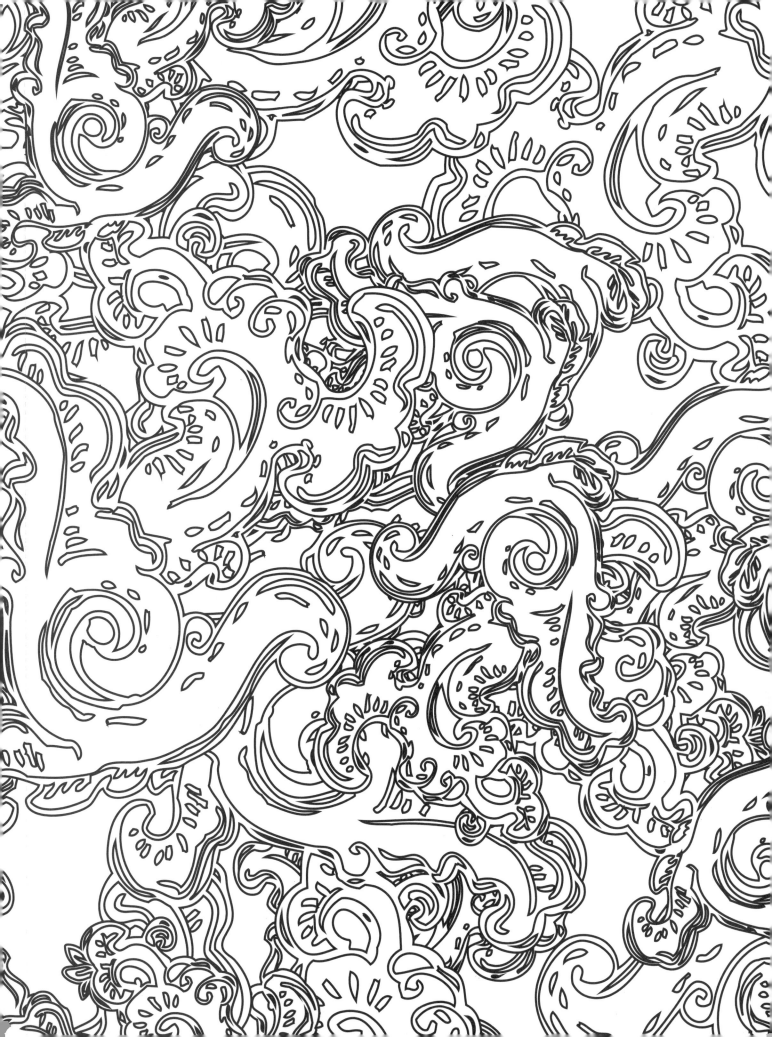

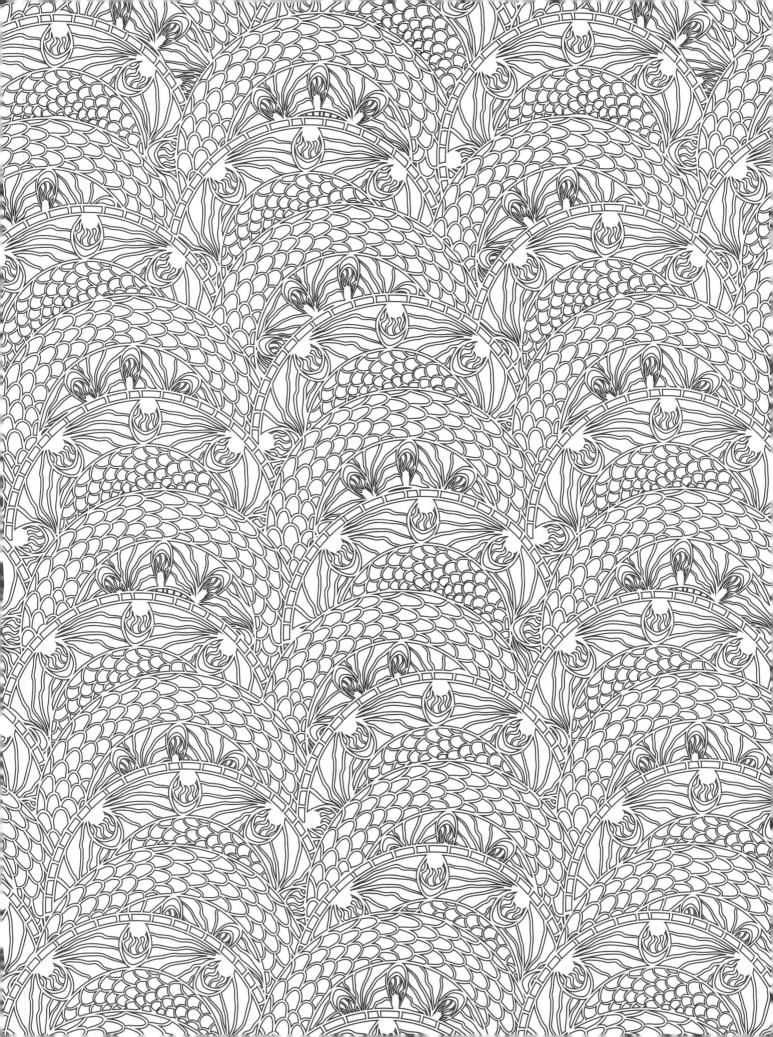

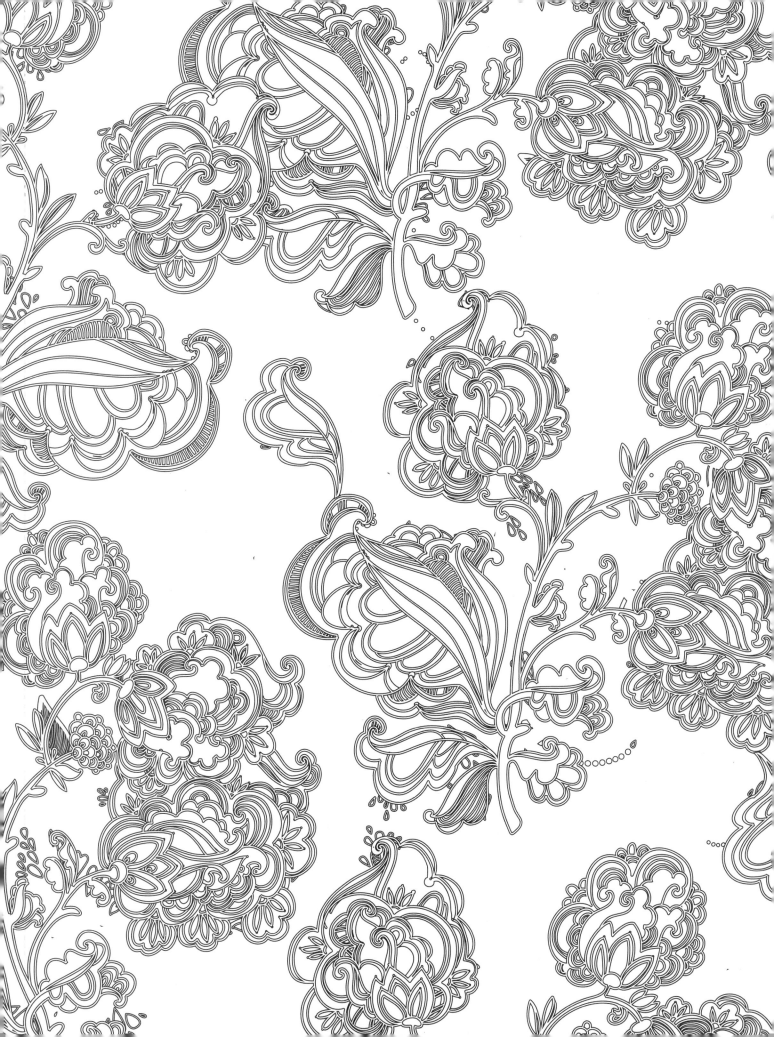

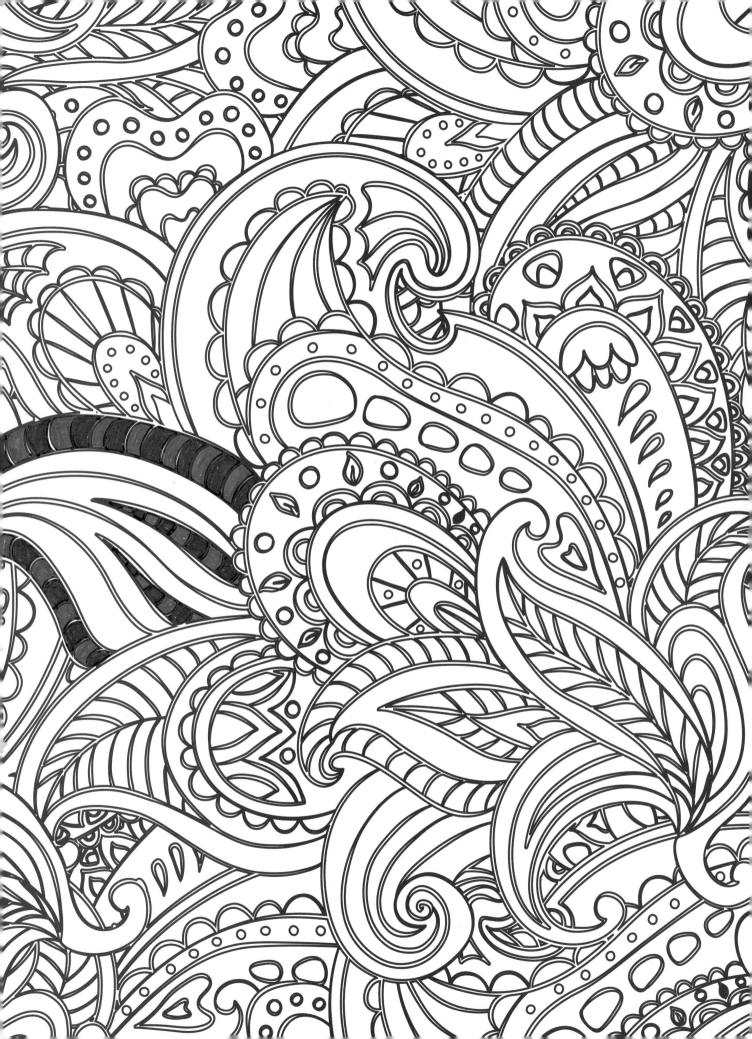

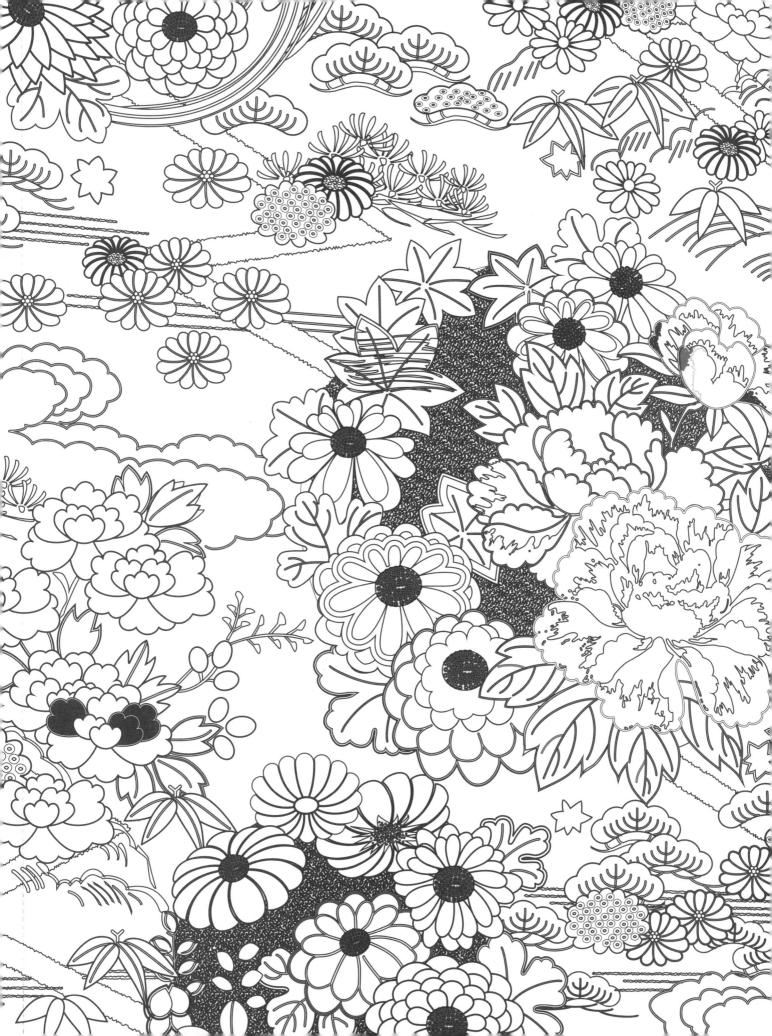

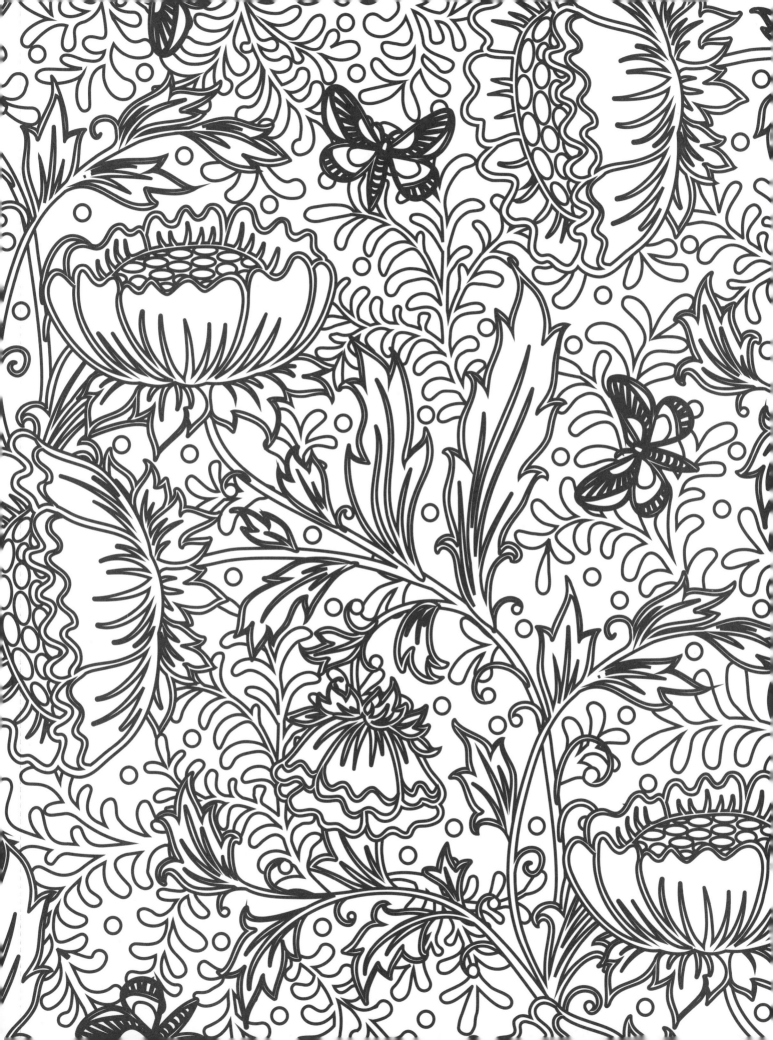

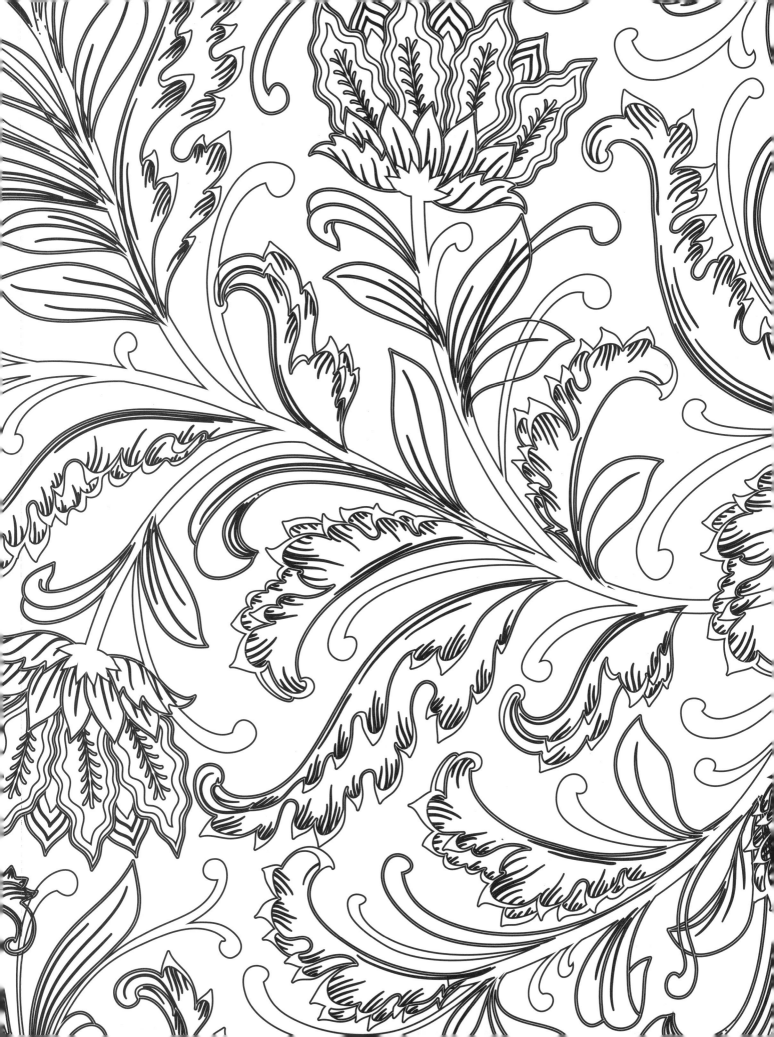

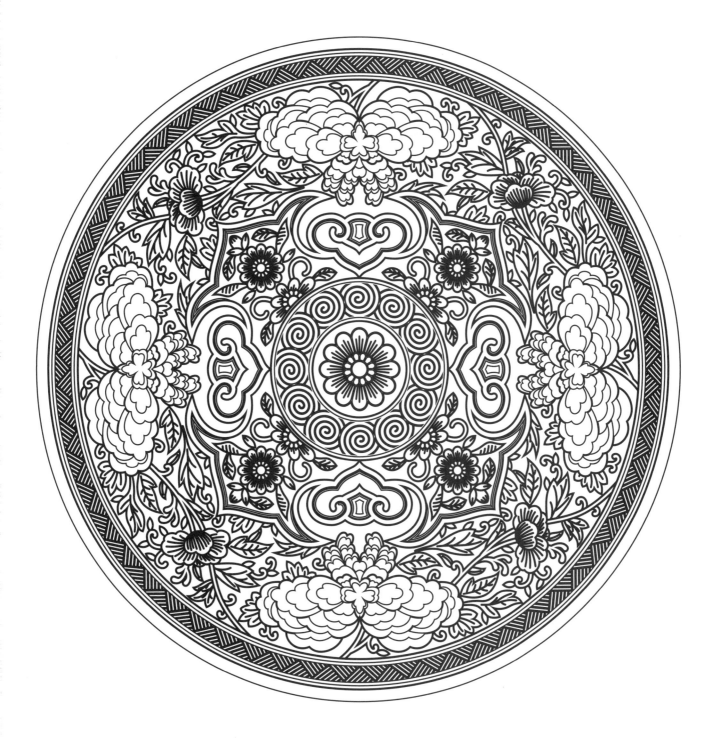

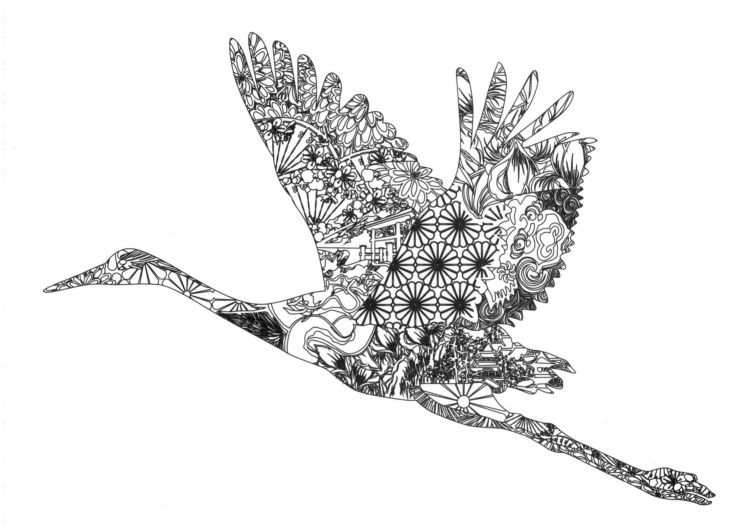

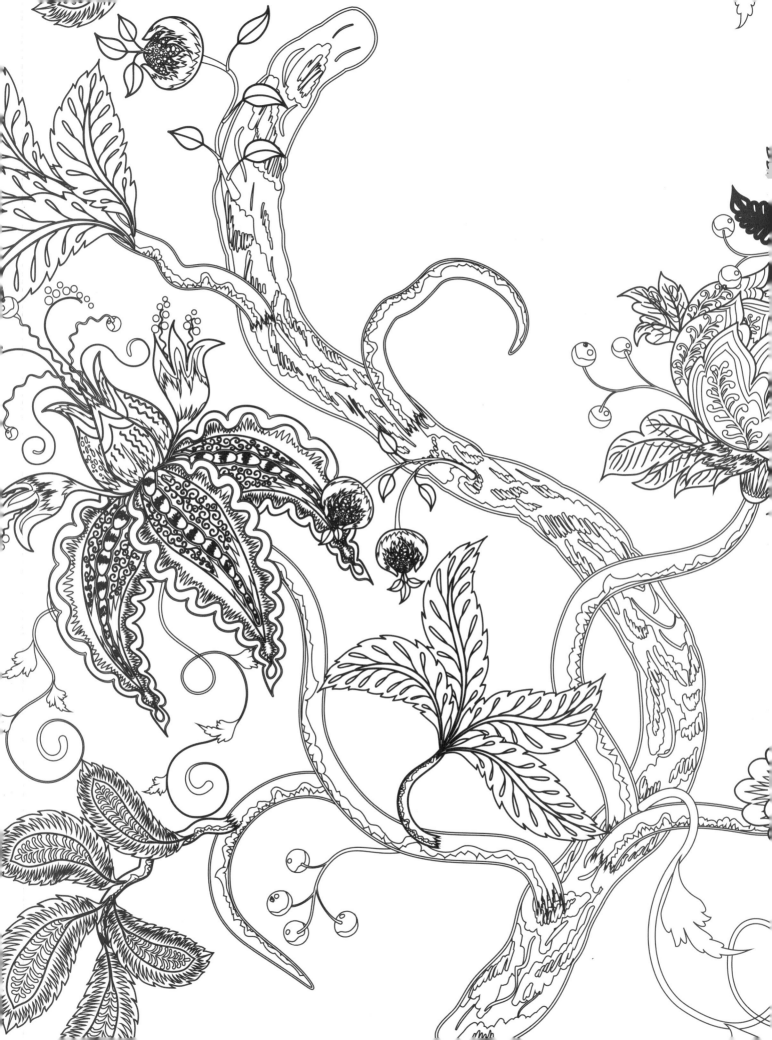

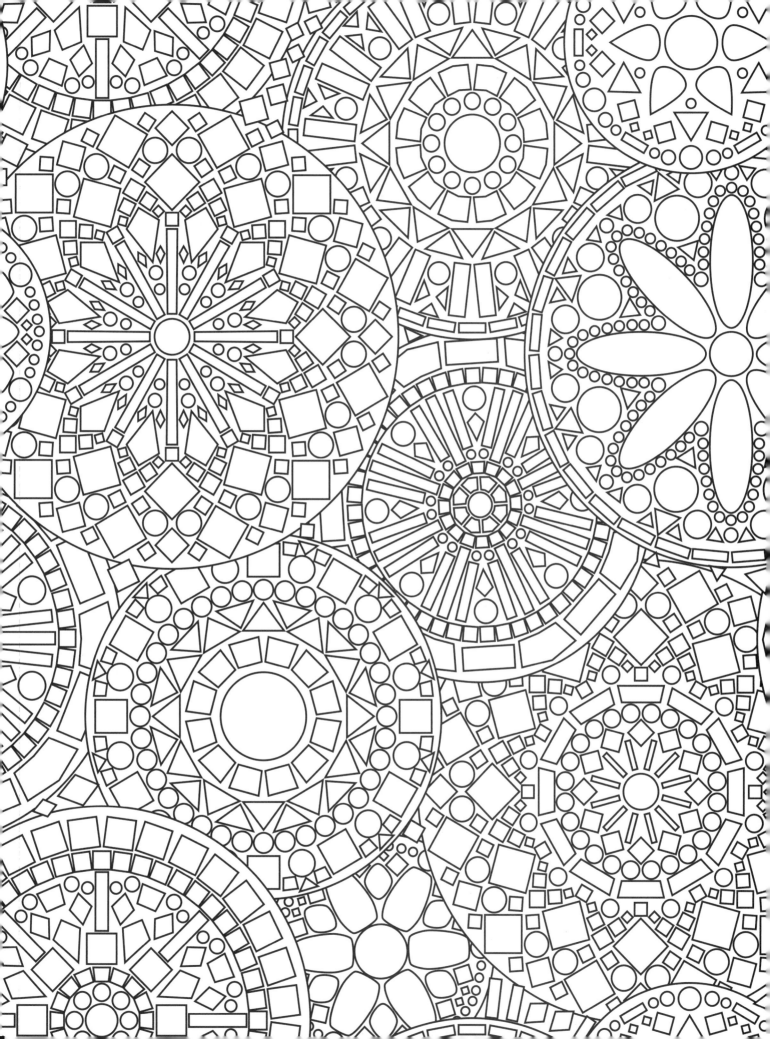

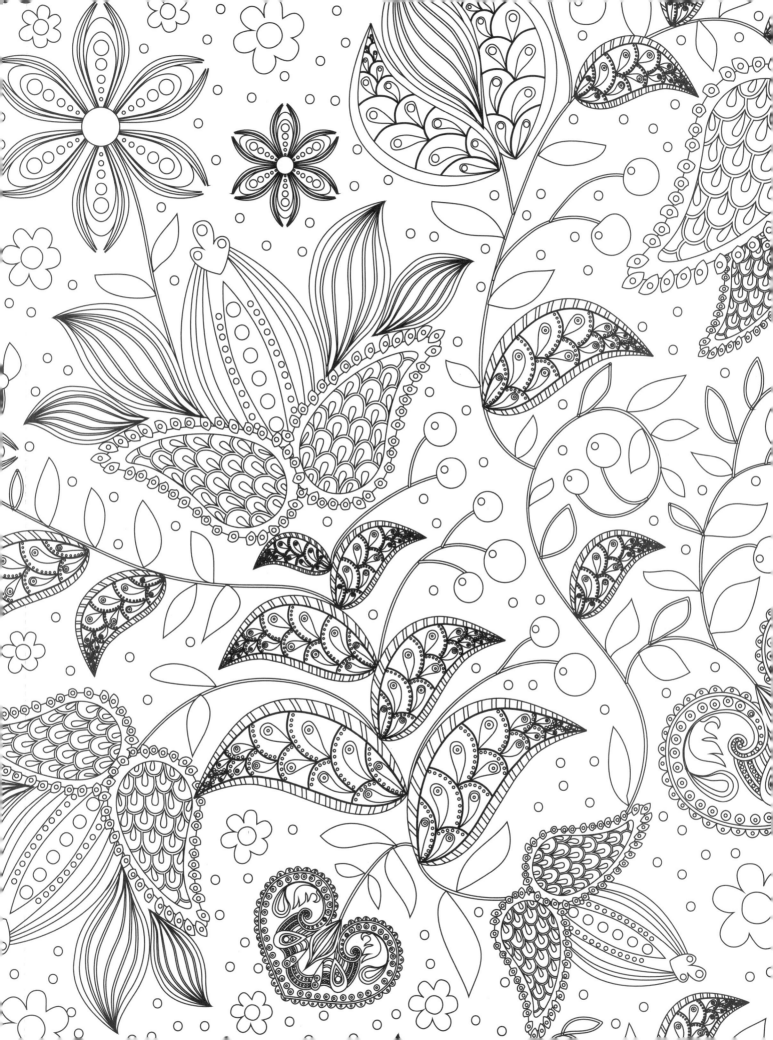

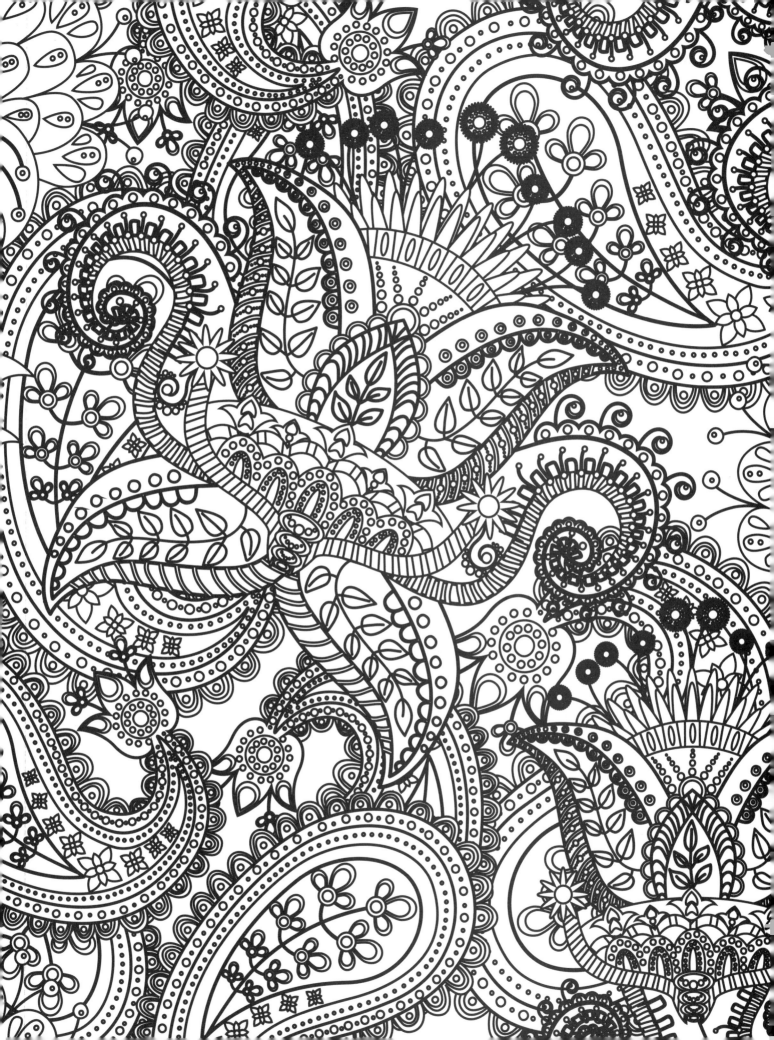

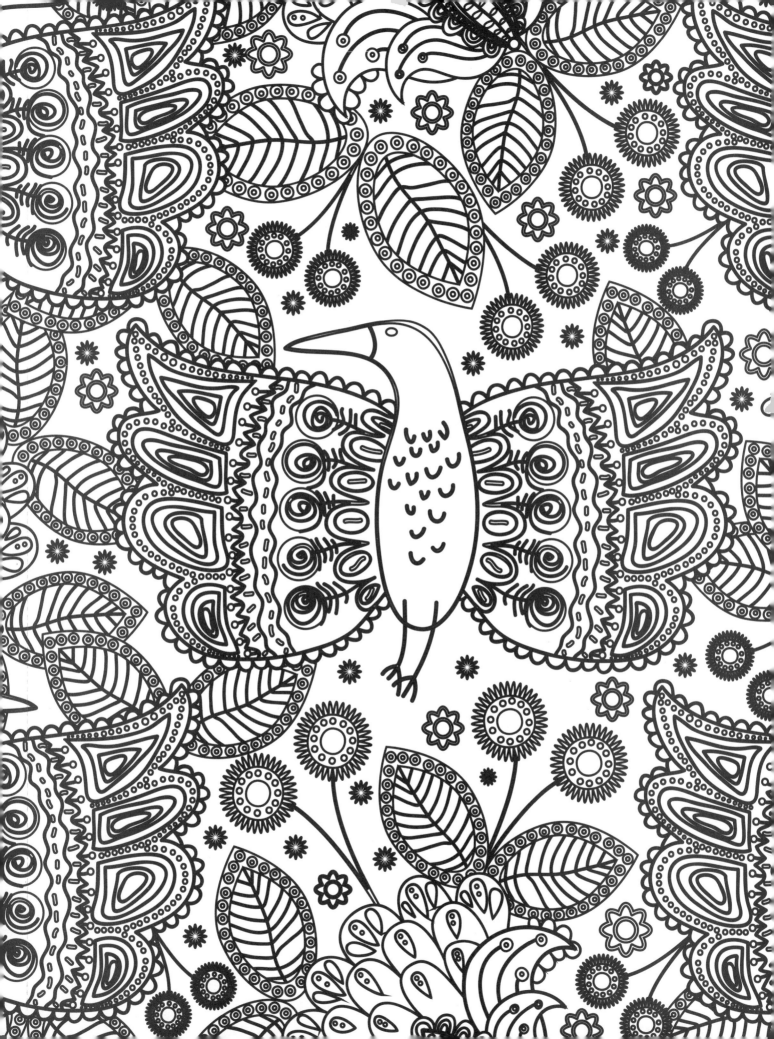

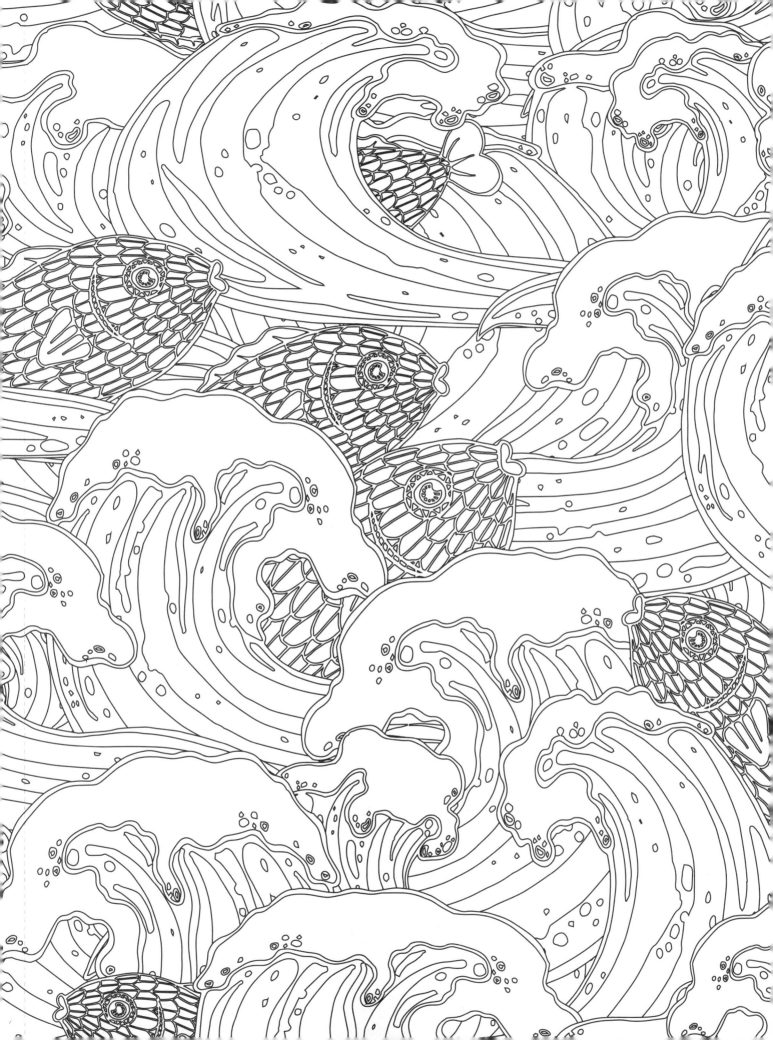

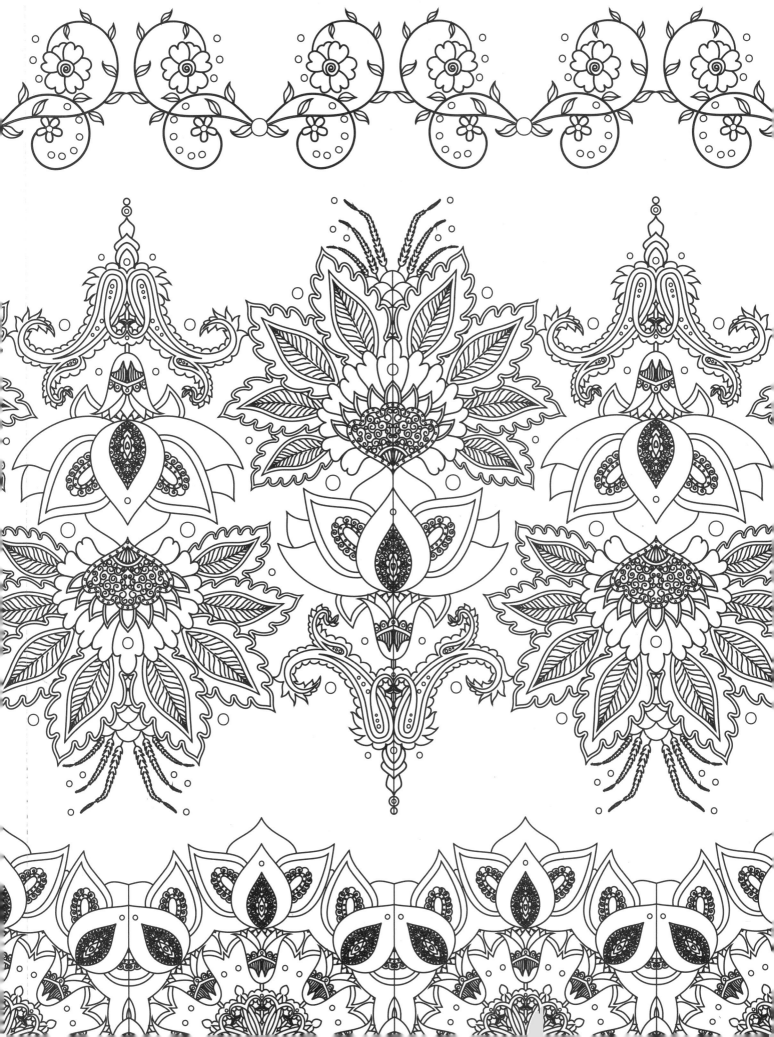

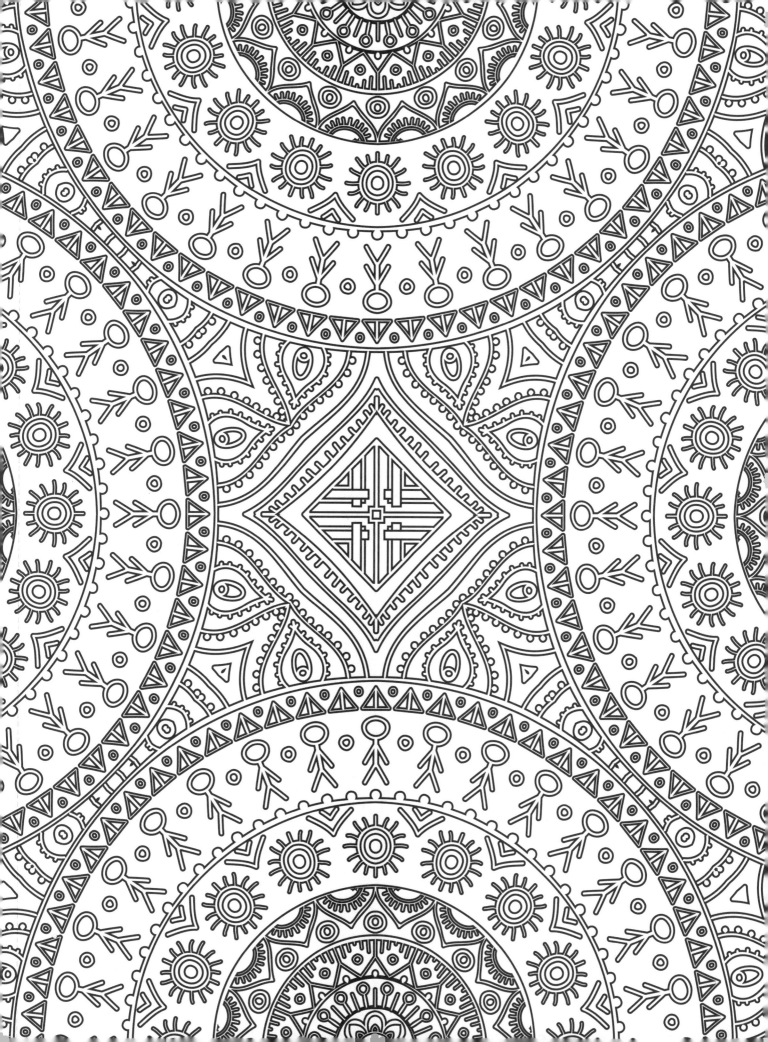

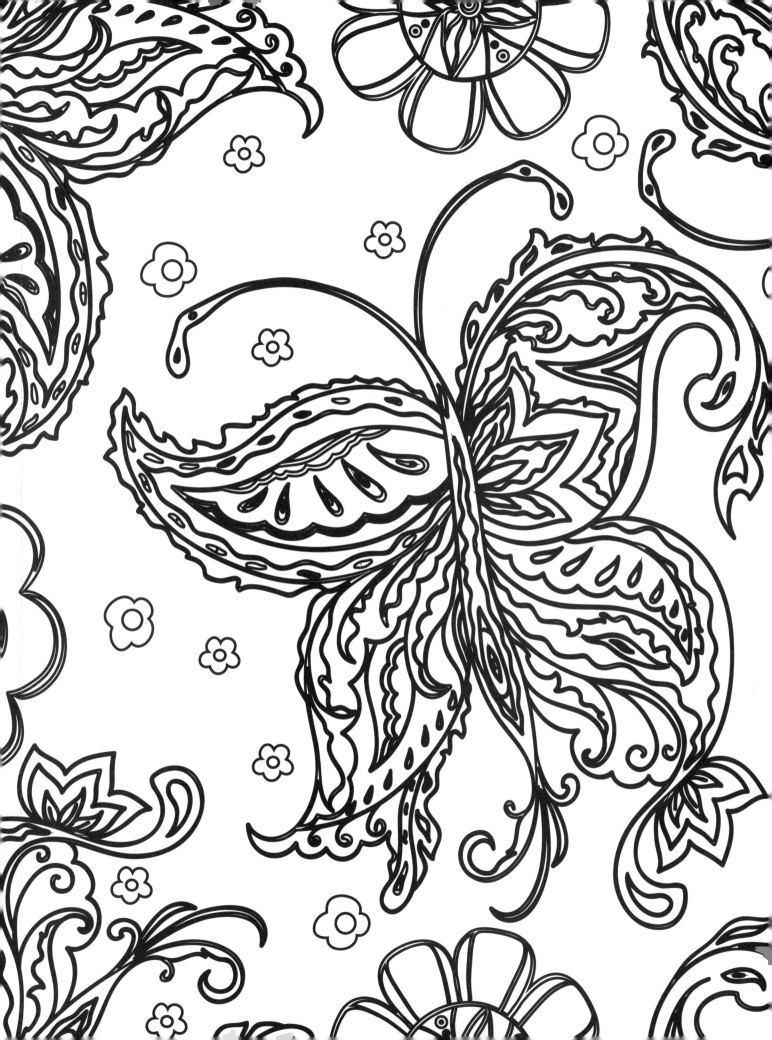

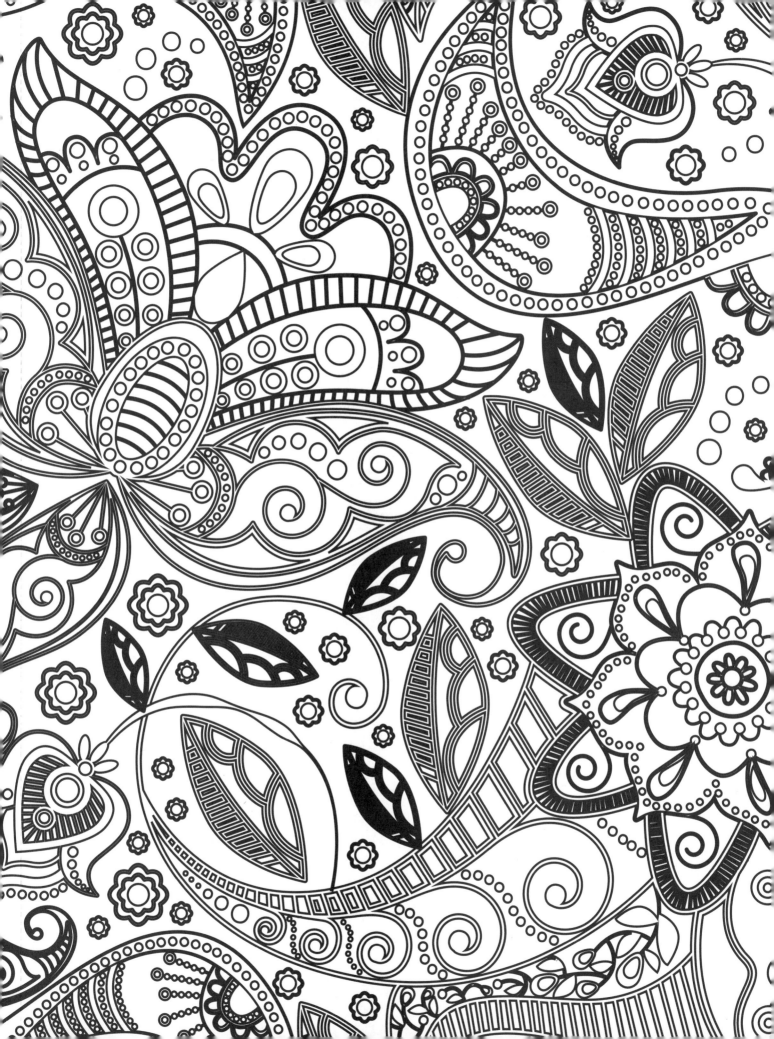

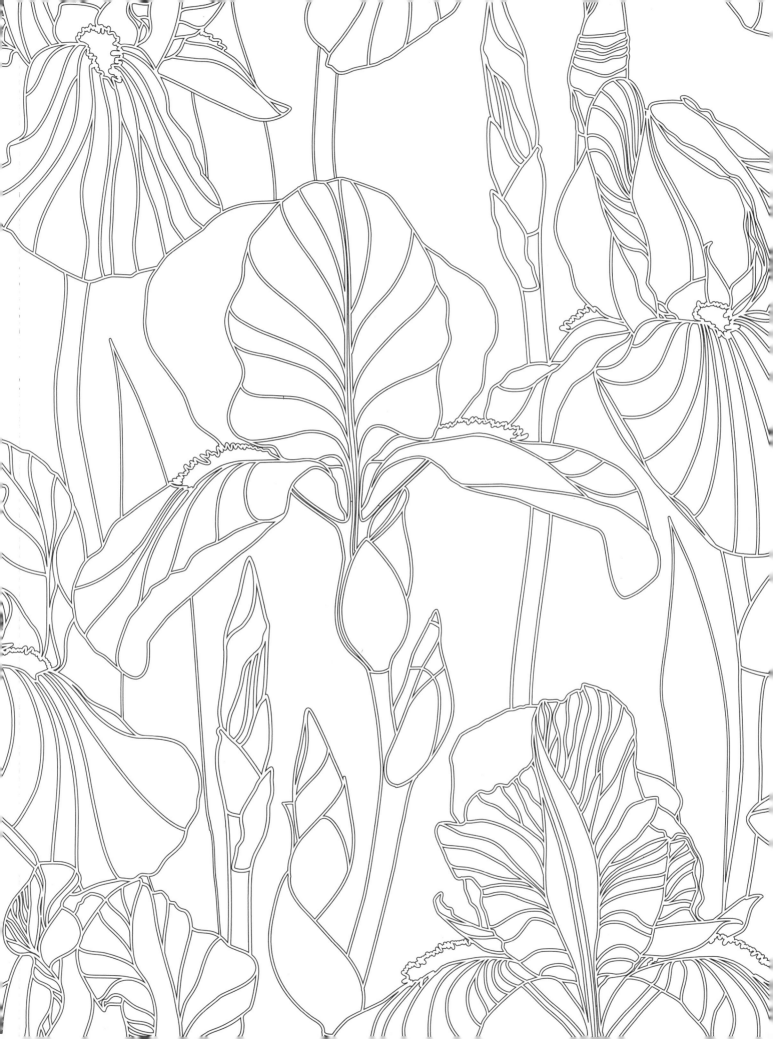

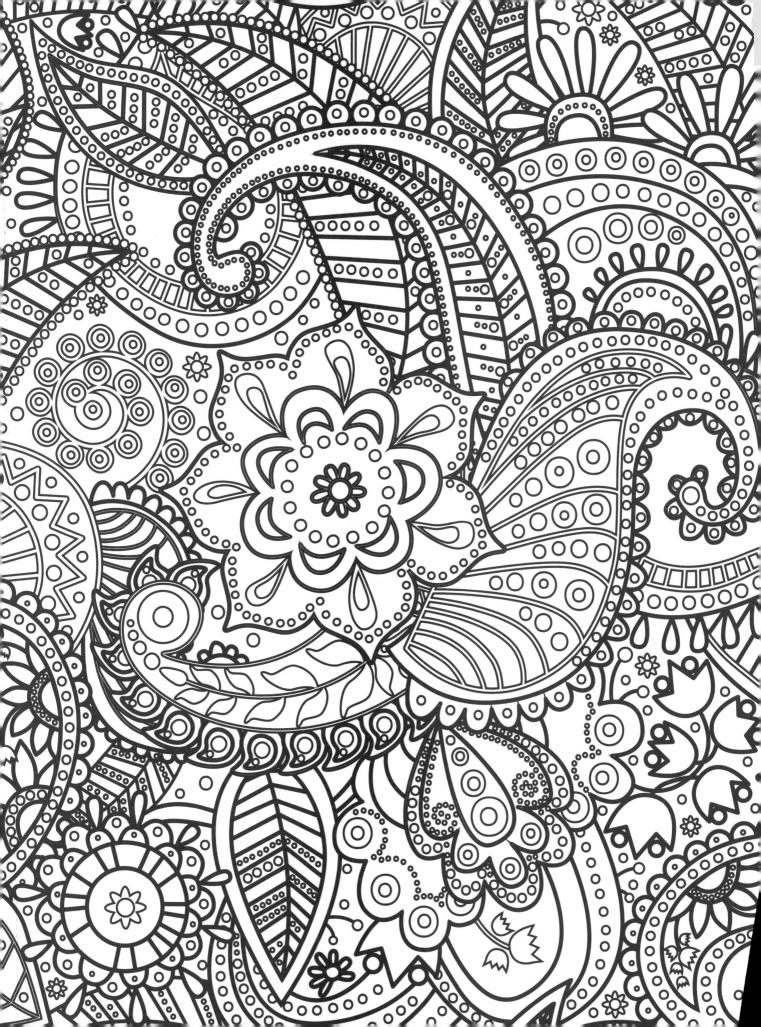

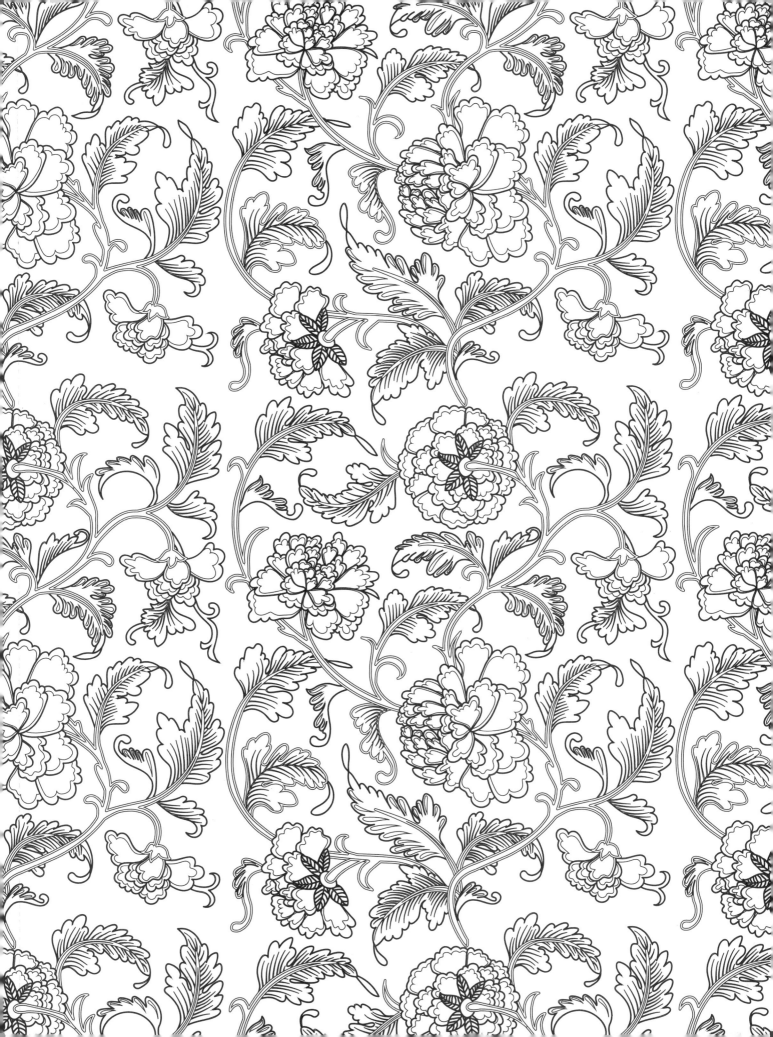

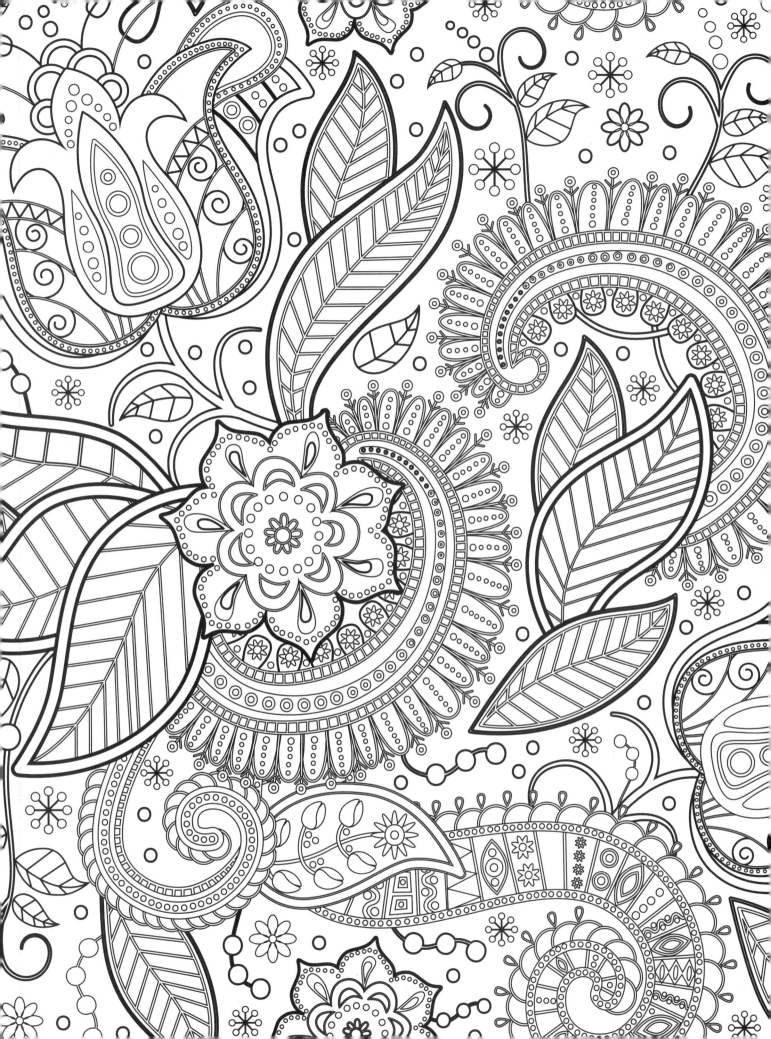

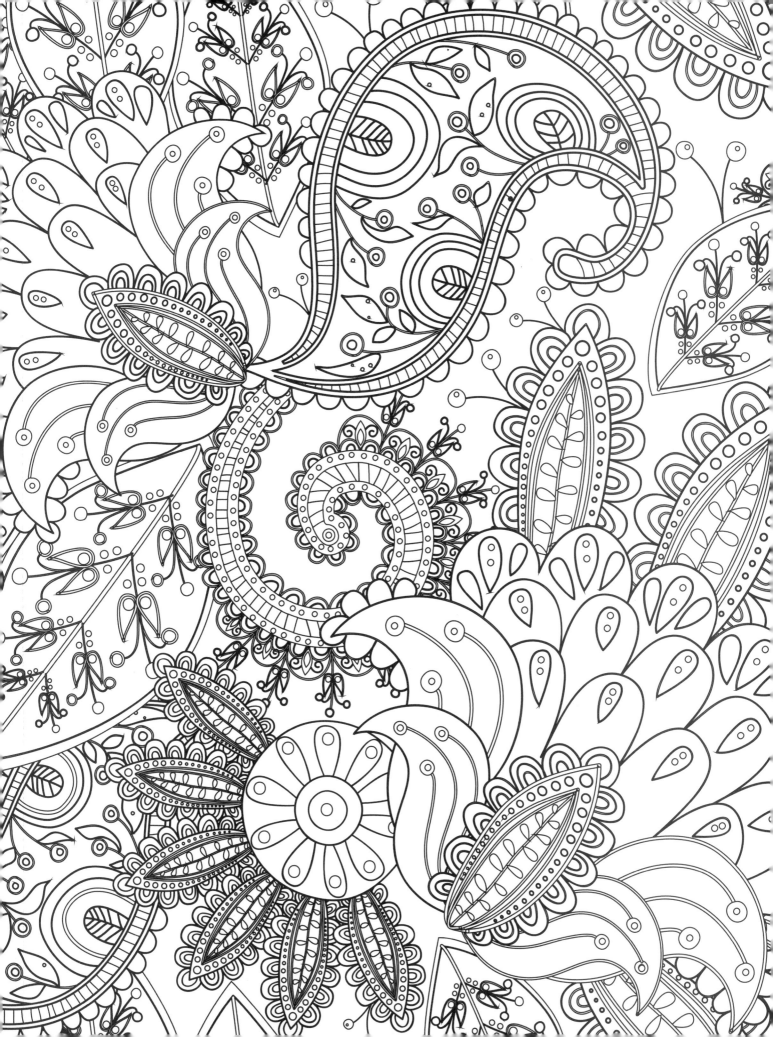

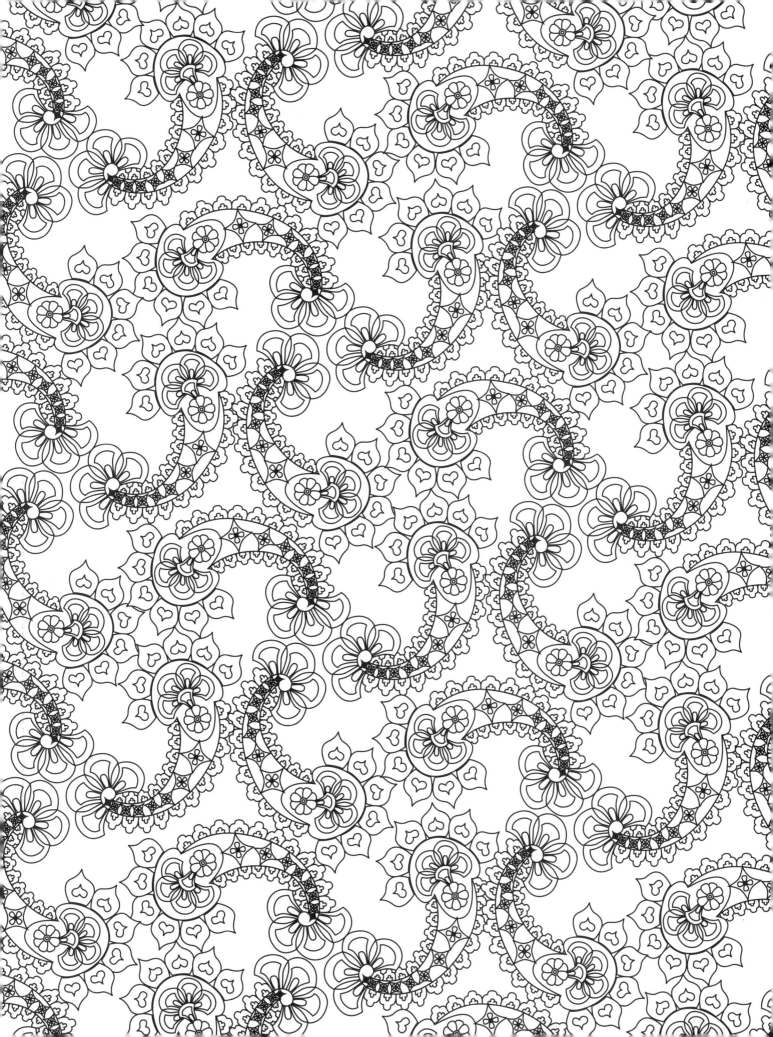

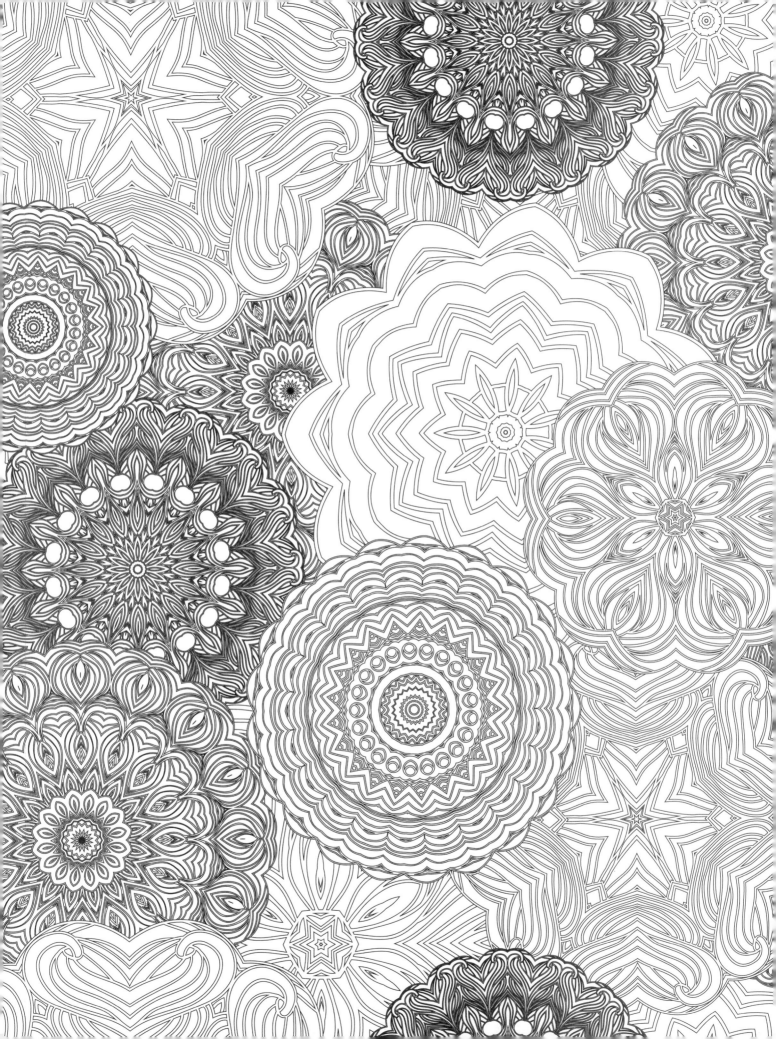

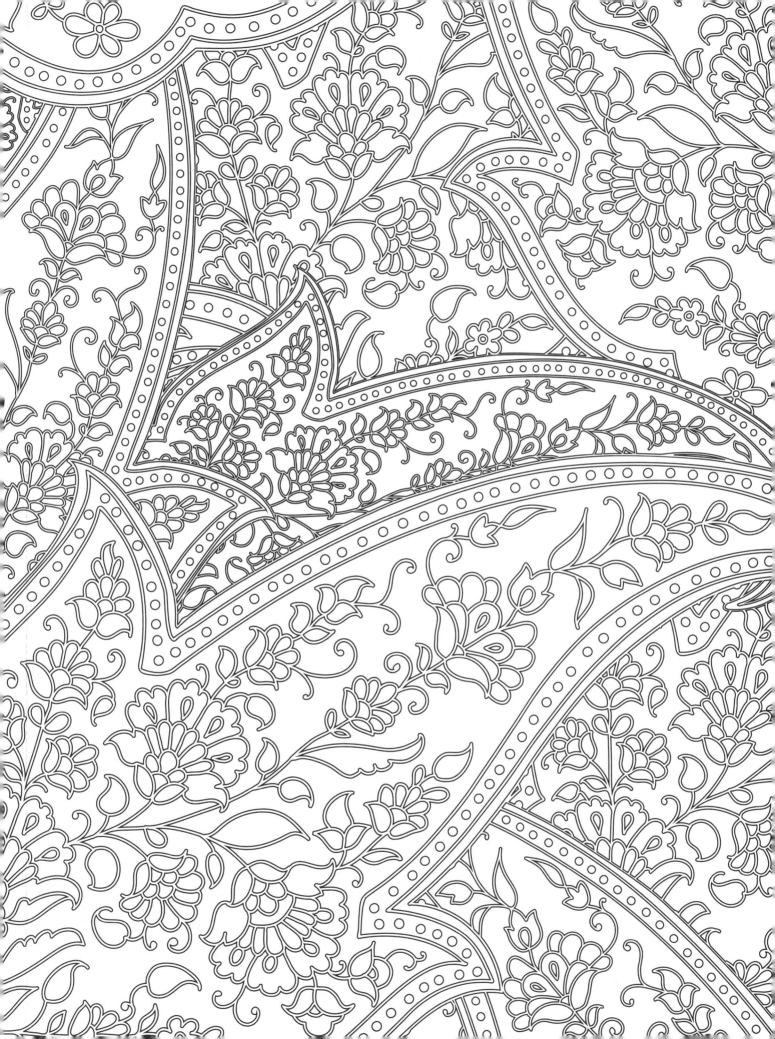

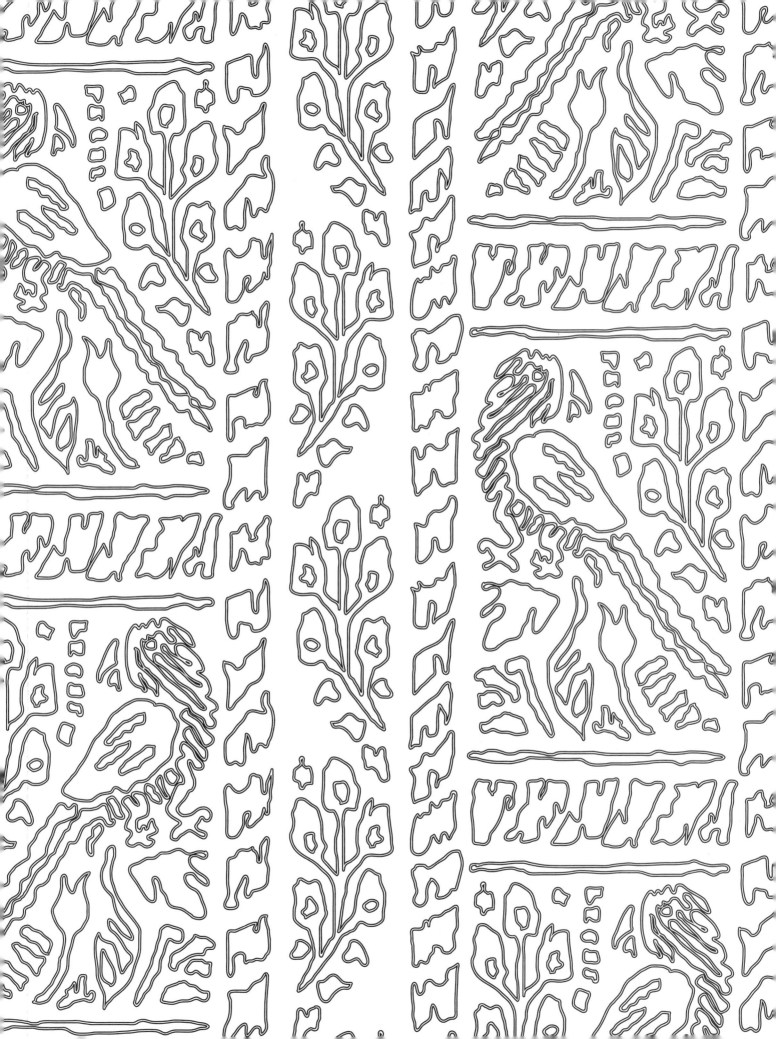

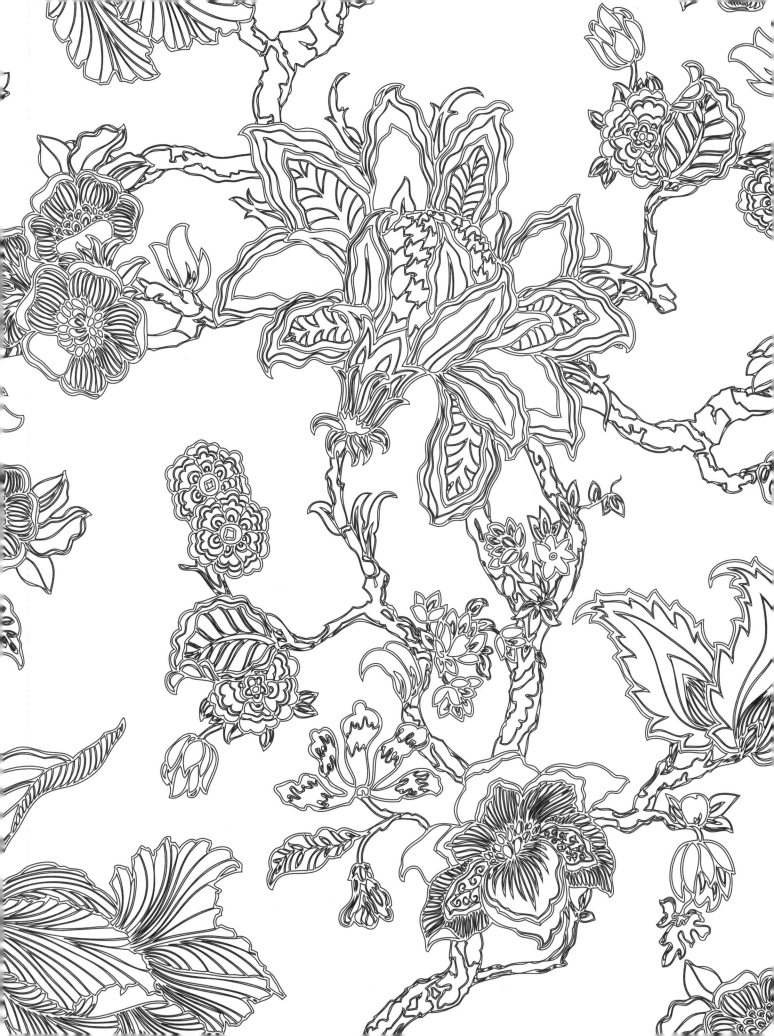

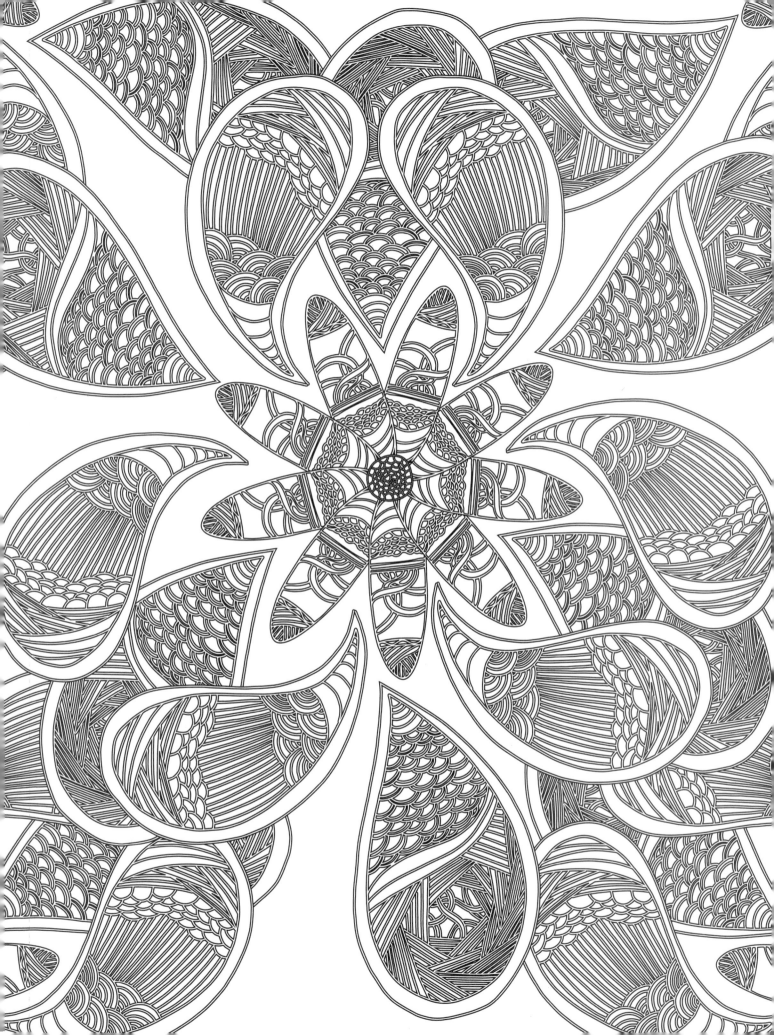

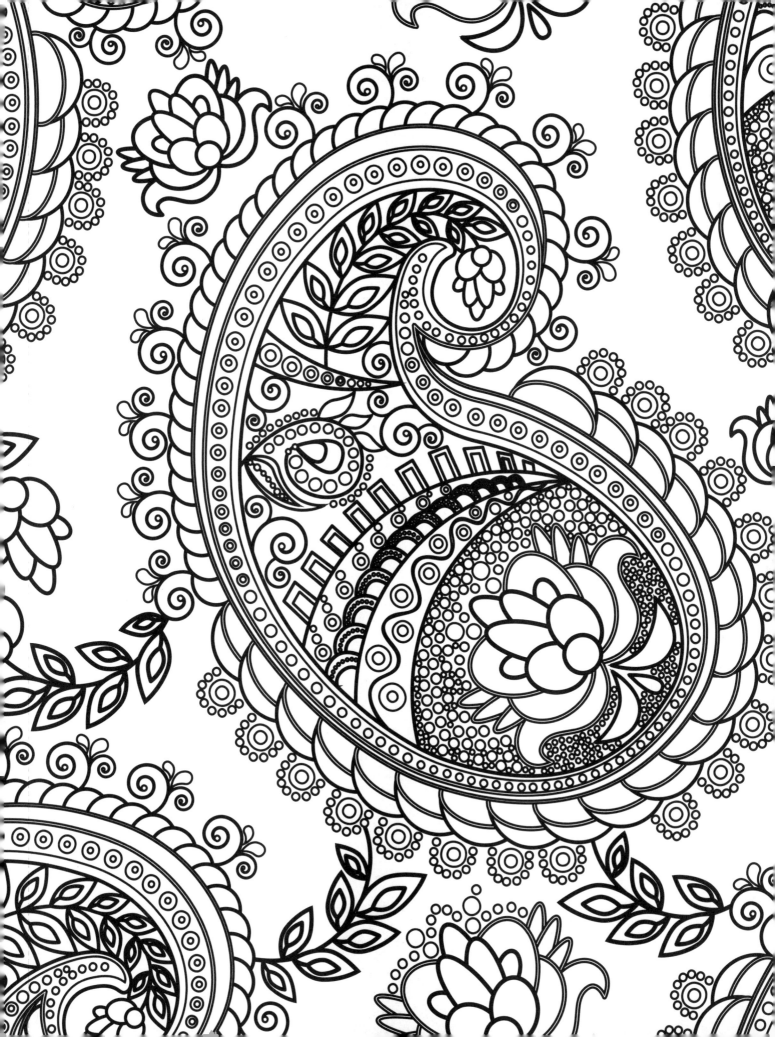

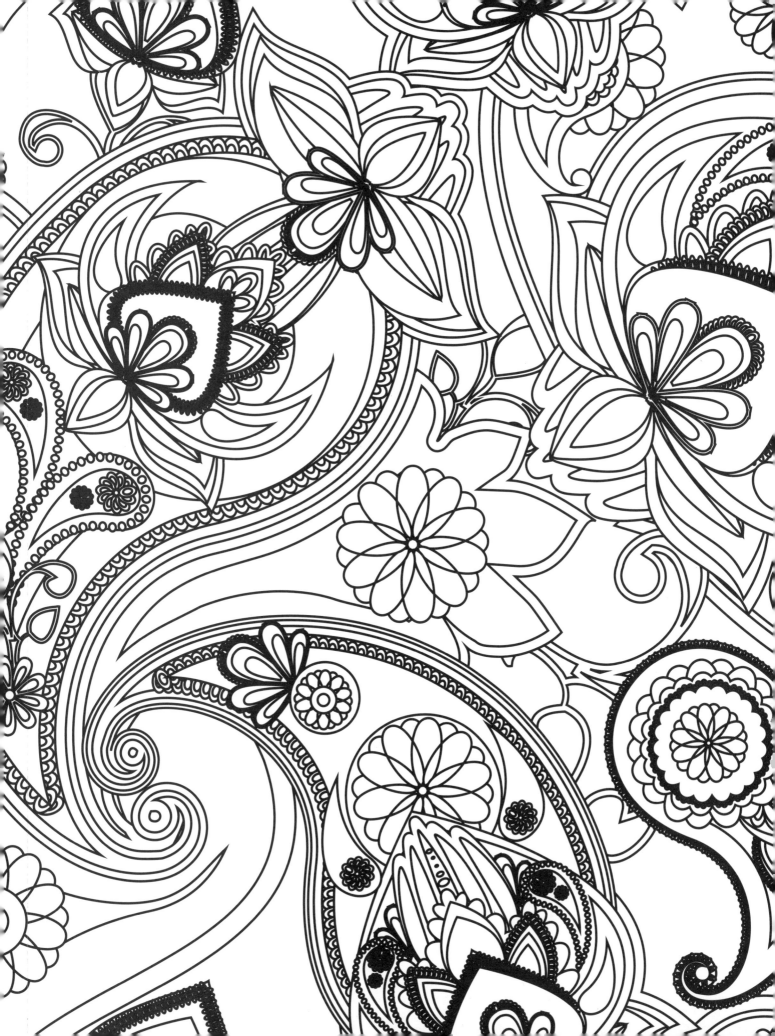

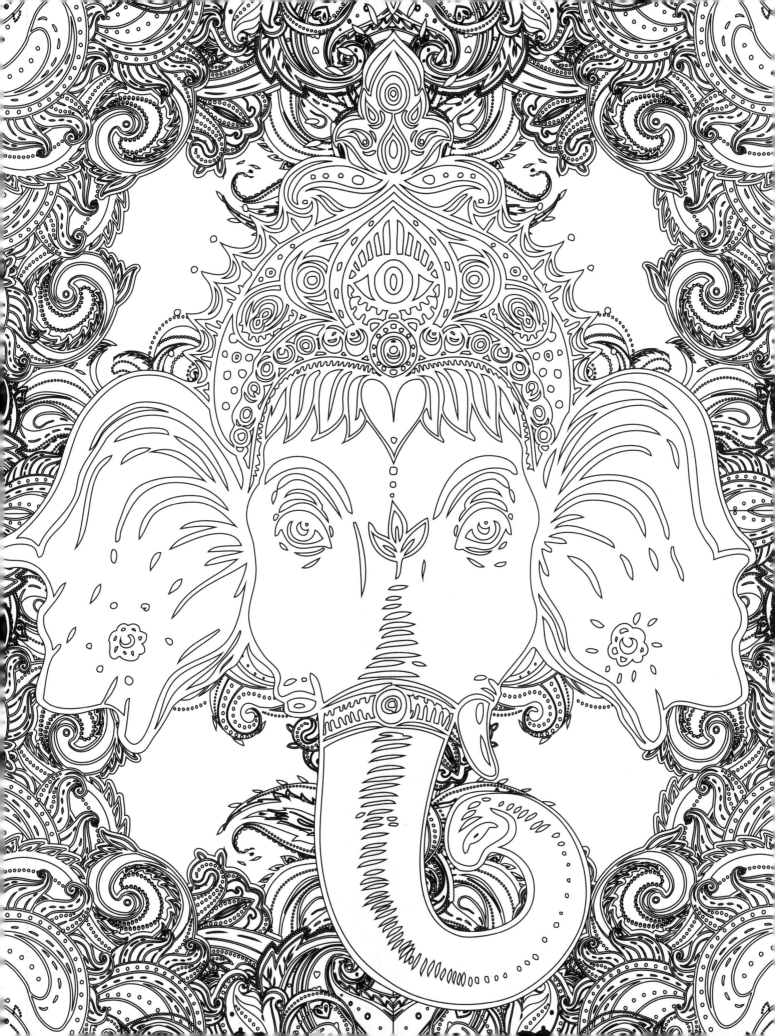

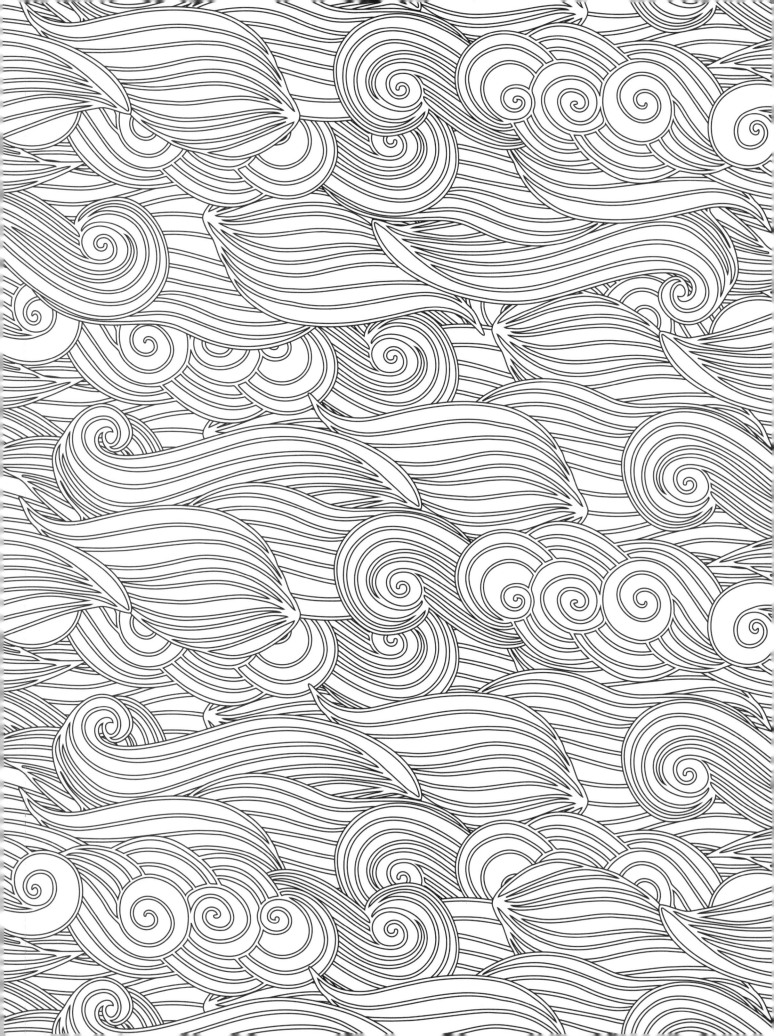

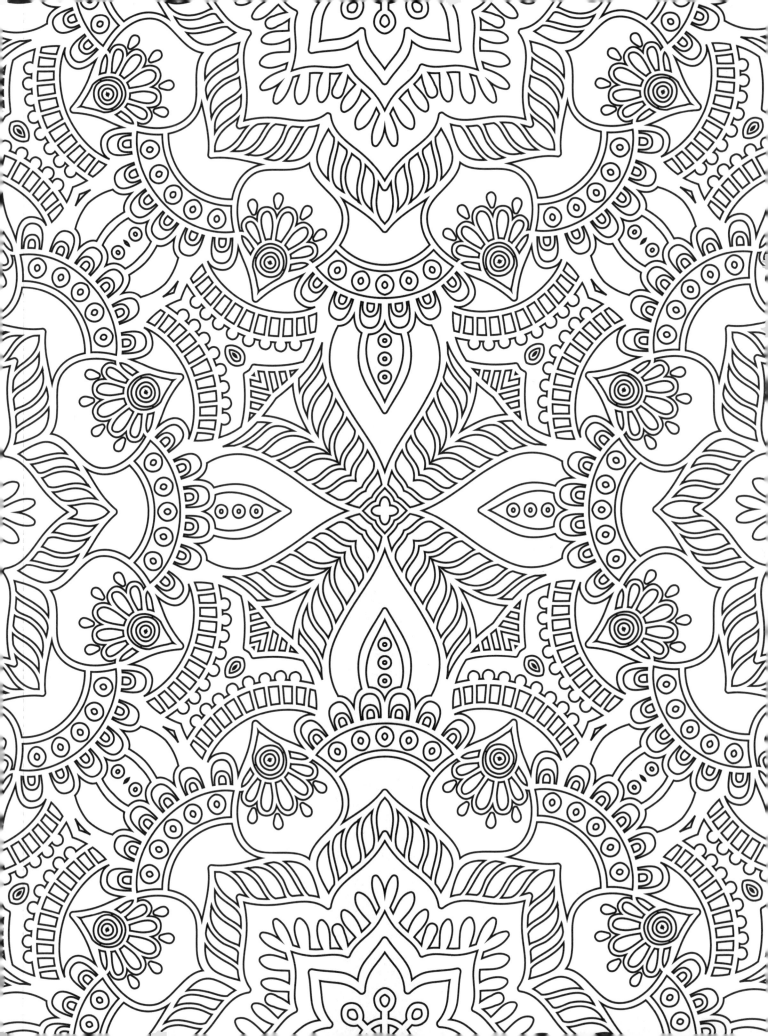

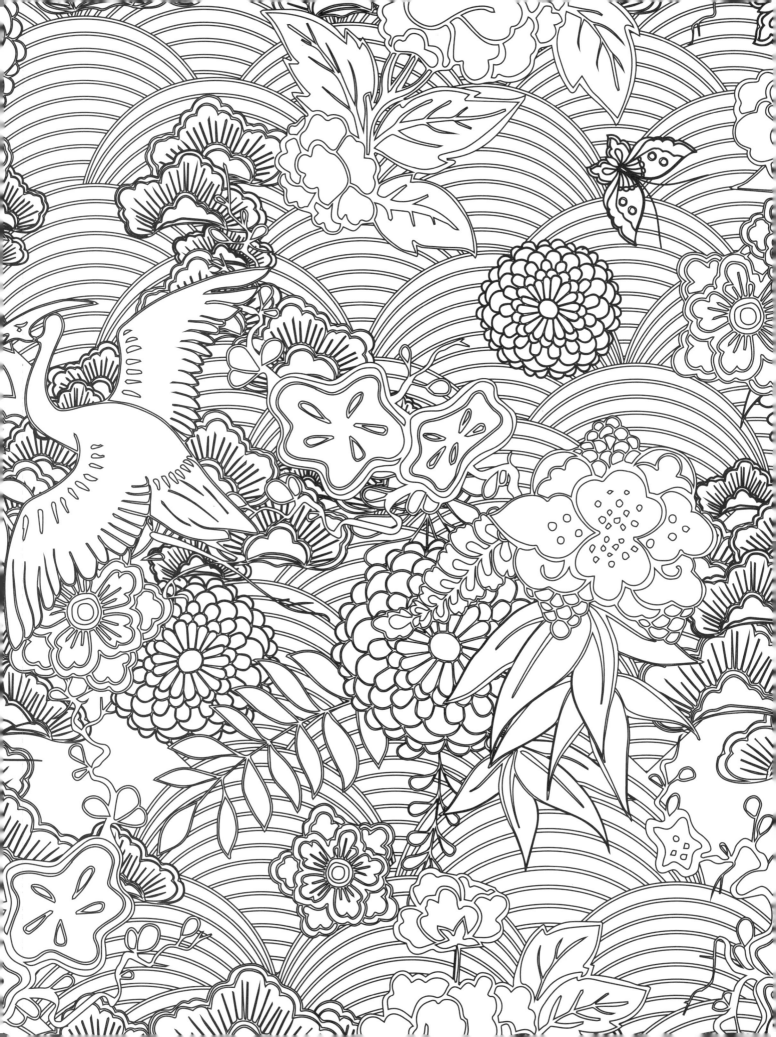

Color Bars

Use these bars to test your coloring medium and palette. Don't be afraid to try unique color combinations!

Color Bars